IMAGES
of America

ALIQUIPPA

IMAGES
of America

ALIQUIPPA

Cindy and Ed Murphy

ARCADIA
PUBLISHING

Copyright © 2013 by Cindy and Ed Murphy
ISBN 978-0-7385-9930-4

Published by Arcadia Publishing
Charleston, South Carolina

Printed in the United States of America

Library of Congress Control Number: 2012955160

For all general information, please contact Arcadia Publishing:
Telephone 843-853-2070
Fax 843-853-0044
E-mail sales@arcadiapublishing.com
For customer service and orders:
Toll-Free 1-888-313-2665

Visit us on the Internet at www.arcadiapublishing.com

To the people of Aliquippa

CONTENTS

Acknowledgments 6

Introduction 7

1. The Early Years 9

2. Building the Community 19

3. Jones and Laughlin Steel Company 39

4. West Aliquippa 53

5. Churches and Schools 63

6. The Business Community 77

7. The Golden Jubilee 109

8. B.F. Jones Memorial Library 121

ACKNOWLEDGMENTS

It is with heartfelt appreciation that we thank Gino Piroli for his unwavering dedication to the history and culture of Aliquippa and for sharing his decades of experience with us. He is truly an asset to our community. We must also thank Stanley Simantiras, Bud Temple, Marie Belcastro, and Butch and Johneen Latone for sharing their Aliquippa knowledge. Thank you Mark Scott for your counsel and years of shared J&L experiences. Our editors and in house critics, Ben, Carrie, and Drew Murphy have patiently watched this book take shape. Thanks for your support and encouragement. Last but not least, we salute the B.F. Jones Memorial Library Board of Directors and staff for providing the resources necessary to make this endeavor successful. Unless otherwise noted, images are from the B.F. Jones Memorial Library.

INTRODUCTION

Aliquippa, a community steeped in a rich cultural heritage, had its beginnings in the late 1800s. The story of Aliquippa involves two separate communities that existed side-by-side for many years before a merger of the two created the Aliquippa that exists today.

A fledgling railroad, the Pittsburgh & Lake Erie Railroad, was chartered in 1877 and completed its rail line from Pittsburgh, Pennsylvania, to Youngstown, Ohio, in 1879. Along this new route, the railroad selected specific areas that were developing and assigned them Native American names. The president of the P&LE had an interest in Native American history and hence named the stations along the route for local tribes and personages. Queen Aliquippa of the Seneca Tribe frequented this area in the early 1700s. It is recorded that she met with George Washington during a council of local tribes. Thus, Aliquippa was one of the names chosen by the P&LE in honor of Queen Aliquippa.

The challenge facing the P&LE was the task of cultivating businesses and passengers to use their new transportation system. Most of the area along this new route was farm-oriented with some pockets of small industries. One of their more interesting ideas was the development and construction of an amusement park near Aliquippa. This was meant to encourage passenger traffic from both Youngstown and Pittsburgh as the new park was about midway between both cities. Aliquippa Park, as it was called, was a successful venture. The park's tenure was about 25 years and it served well as an entertainment destination in the late 1800s. During the park's years of operation, the community of Aliquippa (present-day West Aliquippa) grew as an industrial site with a number of small businesses including a shovel factory and a brewery. The park was eventually purchased by Jones and Laughlin Steel Company and razed to provide land for the new mill.

Woodlawn, the community just to the south, was principally a farming community. The name Woodlawn was suggested by the wife of a prominent landowner in the area, James McDonald, and was accepted by the railroad as a station stop along their new line. The McDonald Farm, along with the Douds Farm, would comprise most of the area that Jones and Laughlin would later purchase to provide land for the new mill and town.

In addition to farming, there was a church-affiliated academy, Woodlawn Academy, that was very successful and also a few businesses that supported the farming interests.

The P&LE station in Woodlawn also served an area known as White Oak Flats. This community was along Brodhead Road and boasted gristmills, a blacksmith shop, and a post office. Brodhead Road was the principal road connecting White Oak Flats to Pittsburgh and Monaca. The advent of the railroad provided better access to markets and suppliers for White Oak Flats. The connecting road to Woodlawn and the P&LE was Sheffield Road, which traversed Logstown Hollow along its route. Growth in Woodlawn was slow during this time period in comparison to its northern neighbor, Aliquippa. This situation would change significantly in the early years of the 20th century.

Pittsburgh was rapidly becoming the steel center of America. Steel companies headquartered in Pittsburgh were looking to expand their growing businesses. Most of the desirable property

sites in Pittsburgh were confining, as the city had grown along the three rivers. Property outside of the city, along the Ohio River, was being viewed as desirable for steel mill locations. A case in point was property along the west bank of the Ohio River near Woodlawn and Aliquippa. The Jones and Laughlin Steel Company (later, Jones and Laughlin Steel Corporation) targeted this seven-mile stretch of land as the location for their planned, fully integrated steel plant. Property was purchased in the early 1900s, construction of the plant started in 1906, and the first operations began in 1909.

The most ambitious part of J&L's plan was not only the construction and operation of the steel plant but also the development of a community to serve the needs of their workforce. At the time of construction, many industrial cities were contending with the scandal of the deplorable living conditions of their employees. People living in shantytowns, which sprang up around the mills, were suffering from outbreaks of cholera and typhoid. In an effort to provide better living conditions, the management of J&L decided to build a utopian community for its workforce. J&L planned to build a community near their mill to house and provide for its workers in a fashion not yet in place anywhere in the rapidly growing industrial areas of Western Pennsylvania.

J&L created a separate arm of the company in 1909, The Woodlawn Land Company, and charged them with the task of planning and building the community. The city would have paved streets, a transportation system, brick homes of all sizes, an educational system that was one of the best in the country, and businesses to satisfy the needs of their employees. All residences had indoor plumbing and electricity .This planned community was advertised in a publication entitled *Woodlawn on the Ohio*. The approximately 30-page book fully described the community with photographs of home sites, streets, sidewalks, and the business district. Also contained in the book was a financial roadmap to home ownership in this new city.

The city was laid out in 12 plans, and construction began in earnest along with the mill. J&L's planned community was successful beyond belief, creating a utopia that was recognized throughout the Eastern United States as a wonderful place to live, work, and raise a family.

It must be noted that Woodlawn was a community of approximately 600 people when J&L began the construction of the mill and community. They knew there would be a large influx of people in a very short period of time to staff and operate their mill. Most of the industrial sites during this time period were staffed by a large contingent of European immigrants. J&L employed recruiters that they dispatched to Eastern Europe to recruit workers for their new mill. These hardworking immigrants came to America and Aliquippa/Woodlawn ready to work hard for a new life. They brought with them century old traditions, languages, customs, and a skill set that would build the foundation for Aliquippa's unique status among industrial cities.

The nationalities and countries represented were numerous, which presented a problem for both the mill and the community. The problem of the language barrier was handled within the plant by assigning workers of the same nationality to a specific department in the mill with a bilingual supervisor.

Outside the workplace, the neighborhoods developed in much the same way. Nationalities settled in the plans where a common language was spoken. They opened businesses, established churches, and created social networks that allowed their strong traditions to continue without the need to overcome an immediate language barrier.

Aliquippa has a unique history as a small farming community that was transformed into a worldwide industrial giant in a matter of a few years. This book will explore that fascinating story and also provide a nostalgic look at the community forged by steel and people.

One

THE EARLY YEARS

In June 1878, the Pittsburgh & Lake Erie Railroad leased a 100-acre tract of land, known as Jones Woods, just south of present-day West Aliquippa, to build an amusement park. Aliquippa Park, as it would be called, was part of the P&LE's plan to ensure the financial success of their new railroad. The park was comparable to amusement parks throughout the country, featuring a carousel, roller coaster, dance hall, eateries, toboggan slide, photographic gallery, baseball grounds, tennis courts, and concessions of all descriptions. A laughing gallery was also featured. There were four rustic wooden bridges that crossed Jones Run in several locations. The leased property was a beautifully wooded tract of land with a stream and easy access to the Ohio River. This small, riverfront community was a bustling business town, as opposed to its southern neighbor, Woodlawn, which boasted a general store and a livery stable.

The park opened for visitors on July 1, 1880, and enjoyed immense popularity for over 25 years. It closed its doors on January 7, 1907, when the leased property was sold to the Jones and Laughlin Steel Company for construction of their proposed steel mill. J&L would use two of the park's buildings for office space as their plant grew and took shape.

In addition, to the purchase of the Aliquippa Park property, J&L would also take ownership of several large farms along the Ohio River in the area of Woodlawn. These properties and others would eventually become the site of the sprawling steel plant and the city of Aliquippa.

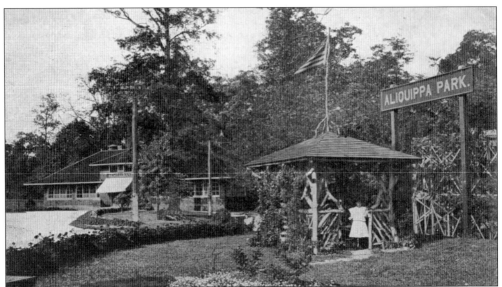

One of the two entrances to Aliquippa Park was located near present-day West Aliquippa. The park was a popular destination for school outings, company picnics, and family reunions. On May 30, 1883, the park enjoyed record attendance when 2,000 visitors purchased a ticket to enjoy the many attractions. The park's restaurant can be seen in the background.

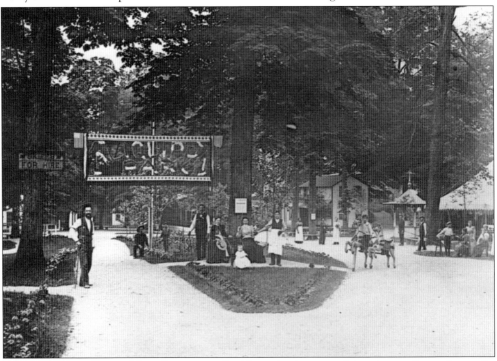

The park featured beautiful gardens, ornate buildings for dining and dancing, and a rest house for the ladies and children. In the early years, it had an open-air carousel. A roller coaster, constructed exclusively of wood, was popular with the thrill seekers. A sign also advertised skiffs for hire to be used on the nearby Ohio River. There was also an arbor with Aliquippa Park spelled out in flowers.

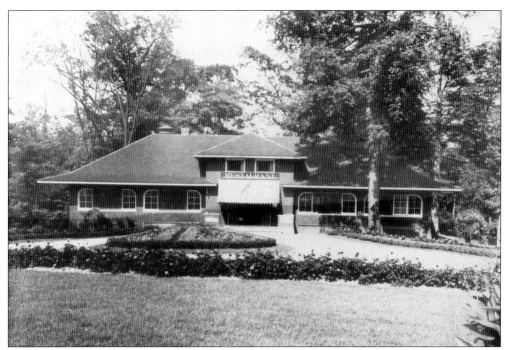

Situated in a grove of shade trees, the park restaurant provided meals and refreshments for park visitors. Lovely, floral gardens were a prominent feature of the park. It should be noted that this leased property was known locally as Jones Woods.

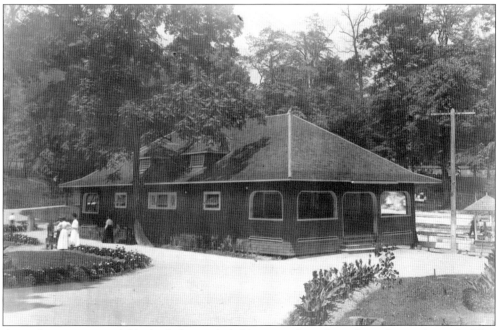

A rest house was available for ladies and children to relax after a long day in the park. This beautiful building provided comfort facilities for women and was located close to the rail line so they could relax while awaiting their train. In the right center of the photograph, a sign can be seen advertising pony rides.

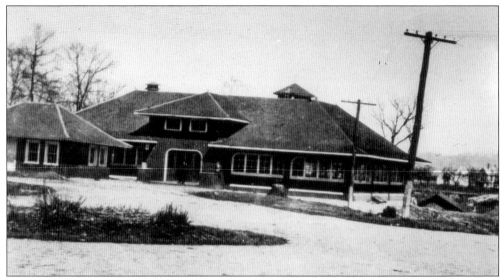

This building was the park's dance hall. After serving over 25 years in that capacity, it was moved on June 8, 1908, to the new mill property and was used by Jones and Laughlin Steel Company as their general offices. It served in that capacity for the Aliquippa Works until 1984 and was demolished in 1990.

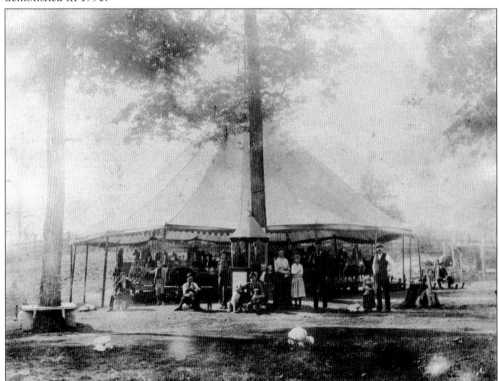

Featured here is the open-air carousel that was one of the park's many attractions. Later, this carousel would be enclosed in a building similar to those found in amusement parks throughout the country during this era. This photograph is the oldest one that will appear in this book, dating from 1880.

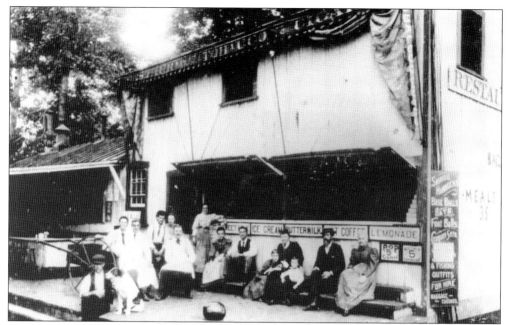

This scene from 1894 depicts several customers and park employees posing in front of the concession stand. The stand not only provided refreshments such as ice cream, lemonade, and sweet milk but also hammocks and swings for resting. Fishing equipment, baseballs, and even croquet sets were for rent. Everything for a relaxing summer day was available.

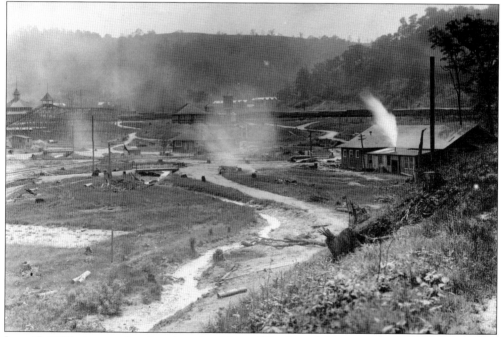

June 17, 1907, six months after the sale of Jones Woods and Aliquippa Park to J&L, work had already begun on the demolition of the park in preparation for building the blast furnaces. Logging of the property had been completed, as evidenced by the many stumps and logs along Jones Run. The roller coaster, carousel, and a few other park structures are visible in the left center.

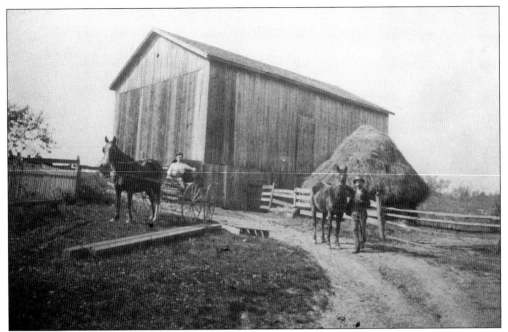

The Temple Homestead began about 1814, when Robert Temple purchased 58 acres of land in an area that became known as Temple Ridge. By 1870, the homestead had grown to 313 acres. This c. 1897 photograph shows the barn that stood on Robert Temple Jr.'s property on the corner of present-day Huron Avenue and Temple Road in Hopewell Township. The two men pictured are sons of Robert Temple Jr., William M. Temple (left), and John McCoy Temple (right).

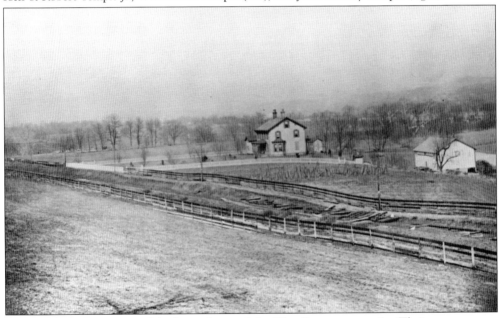

The Douds Farm was one of the larger farms of the Woodlawn community. Their property was situated on the bank of the Ohio River. The Douds Farm property would become the location of J&L's Seamless and Welded Tube Mill Departments, along with other South Mill Departments. The farmhouse, shown here, served as offices for the Aliquippa & Southern Railroad until 1993.

14

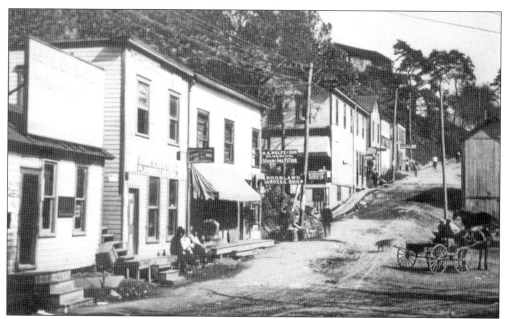

Although Woodlawn was basically a farming community, there were several businesses in the town. Clearly evident in the center is the Woodlawn harness shop and H.S. Wolfe and Son Plumbing. This is present-day Sheffield Road, where Pennsylvania Route 51 enters Aliquippa.

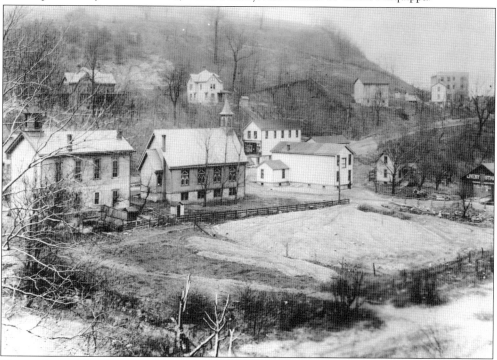

Mount Carmel Presbyterian Church was established in nearby White Oak Flats, present-day New Sheffield, in 1793. In 1895, the church constructed and supported the Woodlawn Academy, featured here. In its final years, the academy building would serve as one of the early public school buildings in Woodlawn.

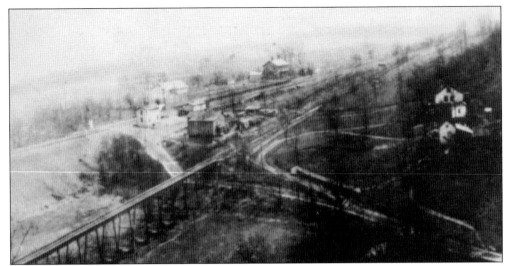

The steel trestle featured in the center belonged to the P&LE Railroad. In 1907, the P&LE would expand their rail line from a single track to four tracks, making it necessary to fill in Logstown Hollow to accommodate the expansion. Soon after the excavation and grading was complete, the trestle was demolished.

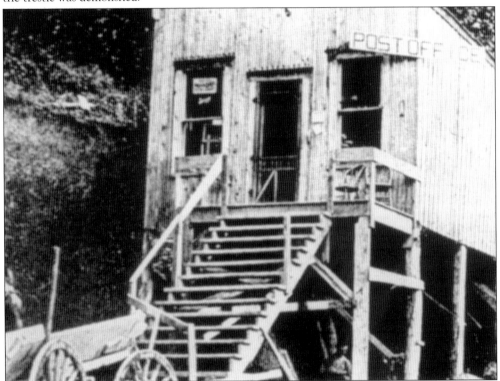

In 1877, the first Woodlawn Post Office was established with C.I. McDonald as postmaster. The McDonald family was one of the prominent landowners in the area. John McDonald bought the land but never lived on it. His sons, Andrew and William, were the first McDonalds to settle the land in 1800. C.I. McDonald's wife, Mattie, suggested the name Woodlawn for the P&LE station that would eventually become the town of Woodlawn. The post office is pictured in 1907.

16

Pictured here is Sheffield Avenue on April 15, 1909, with Logstown Run in the center meandering its way to the Ohio River. The houses and buildings in the left center are located near present-day Spring Street. Logstown Run would eventually be contained in a cement culvert from the Stone Arch at the upper end of Franklin Avenue to the tunnel entrance leading to J&L.

Depicted here is Woodlawn Valley August 27, 1908, shortly before the housing construction began along Sheffield Avenue. There was a watering trough located near present-day Spring Street, and it can be seen in the right center. The hill in the center background would become the Plan 11 neighborhood.

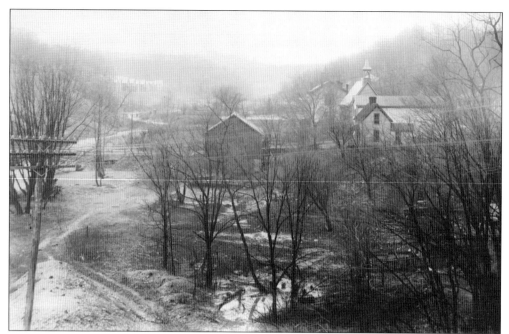

By April 22, 1909, J&L had already begun construction of housing. Highland Avenue was one of the first neighborhoods to be built, and these houses can be seen in the left center background. The Pittsburgh Mercantile Company had a small store on Sheffield Avenue and was located adjacent to the Woodlawn Church and Academy.

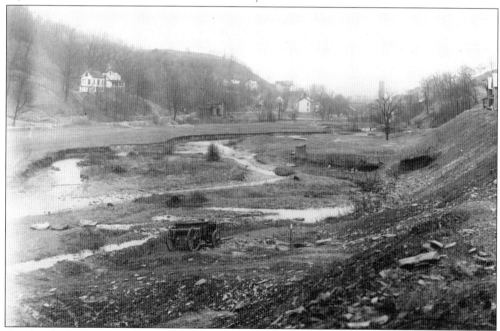

On April 15, 1909, Logstown Run was still running uncontrolled through Woodlawn Valley. Sheffield Avenue, featured on the left, was the main road at the time. Housing can be seen on Highland Avenue in the right center. Work on the culvert to contain Logstown Run was an ongoing project and had not yet reached this area of Franklin Avenue.

Two

BUILDING THE COMMUNITY

Once the Jones and Laughlin Steel Company purchased land and began to build the mill, attention quickly turned to the new town. Wishing to avoid the scandalous shantytowns of most industrial cities of the time, J&L planned to build a first-class community for its workers. Each district was set up as a plan, and some neighborhoods are still known by their plan number. Some of the original numbers were dropped from the vernacular, but residents still refer to certain areas as Plan 6, Plan 12, or Plan 11. The new community's housing and businesses would have all the latest features available. Advertisements for the residences boasted of hot and cold running water, indoor plumbing and baths, electric lights, natural gas furnaces, porches, attics, and front lawns. The business district would have streets paved with bricks, and the residential streets would be paved with macadam. Workers were encouraged to purchase their own homes. An independent land company was established to lend assistance to employees making such a major investment. An excellent school system, a fire department, a police department, and numerous businesses promised that Aliquippa would be one of the finest suburbs of Pittsburgh. Public transportation was not a problem either with the Pittsburgh and Lake Erie Railroad providing easy access to distant places, and the Woodlawn and Southern Street Railway Company operating within the town to make local travel easy.

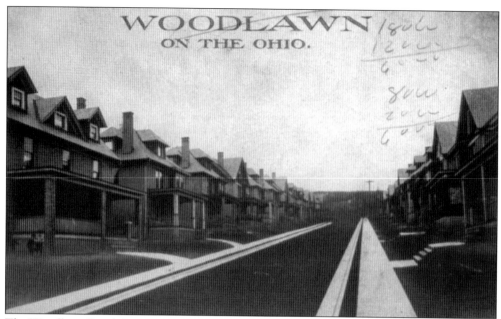

The Woodlawn Land Company was established independently of the Jones and Laughlin Steel Company to oversee the planning, building, and commercial aspect of the new properties in Woodlawn. The photograph here is actually the front cover of the brochure produced to advertise the new suburb of Pittsburgh. The brochure promised a first-class community close to the employees' workplace.

Woodlawn on the Ohio.

Woodlawn, the new city adjoining the new furnaces, steel mills, rod, wire and tin mills of the Jones & Laughlin Steel Company's Aliquippa Department, has become a beautiful new suburb to Pittsburgh, one which the greater city is proud of. It is today a town of over 5,000 inhabitants and is destined to grow in a few years into a busy city of 25,000 or 30,000 people. There is no more active place in the Pittsburgh district today than Woodlawn with its hundreds of pretty homes, its clean paved streets, its dozens of modern stores, its churches, schools, lodges, clubs and its ample transportation facilities.

Woodlawn nestles in a beautiful valley 19 miles down the Ohio from Pittsburgh, in Beaver County, and spreads out its cosy homes upon the surrounding hills. Its streets are paved with brick in the business section and macadam in the residence section, concrete sidewalks, shade trees, sewered and electric lighted. It has every modern utility, such as natural gas, electric light, a pure and potable water supply, and ample police and fire protection. Its school system is splendidly organized and its opportunities for delightful home and neighborhood life are not equalled in this end of the state. The new works are attracting iron and steel workers of the better class and the new town is designed to give them the very best homes amidst the most beautiful surroundings. The houses put up by the Woodlawn Land Company contain from 6 to 10 rooms and bath, are constructed of brick, cement or frame or combinations of these materials, and are in every respect as attractive and convenient as any suburban town in the district can show, and are above the average city home in point of comfort and convenience.

Woodlawn has grammar schools and a beautiful high school, a five-story department store, a score of other stores, banks, drugstores, churches, physicians' offices, and all classes of enterprises.

There is a police department and fire department at Woodlawn and a complete electric police and fire call system. There is also electric light for streets and homes, gas for cooking and light, and a fine system of pure filtered water from artesian wells.

This is an advertisement that appeared in the original brochure. The new steel mill is described along with a detailed description of the planned community. Pretty homes, beautiful surroundings, and every modern convenience awaited prospective buyers. The school system and the fire and police departments are all described in glowing terms. Electric light for street and home, gas for cooking, and pure, filtered water from artesian wells are all promised in this new town.

20

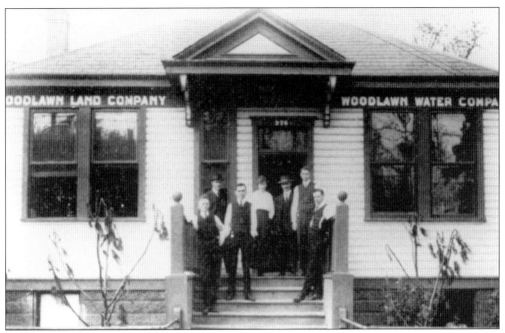

The Woodlawn Land Company office was located on Sheffield Avenue. Among the many responsibilities of the land company was assisting potential home buyers with financing their purchases. Pictured on the front steps of the office in October 1915, employees are, from left to right, Ed Parrott, M.B. Moore, H.C. Clark, Olive Inman, J.G. McCandless, L.E. Winter, and J.C. People.

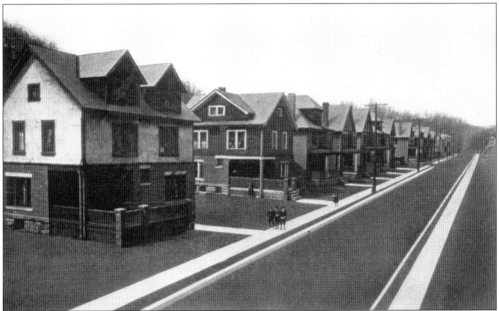

The homes available to prospective buyers were multifamily dwellings, two-family homes, or a wide variety of single family homes as shown here. This section of homes was located on Sheffield Avenue. Note the paved streets and sidewalks. If home ownership was not an employee's choice, the land company also offered rental properties.

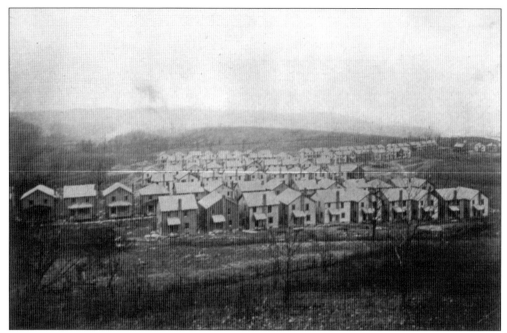

The houses of the Plan 12 neighborhood were described as a colony of good homes. Starting in September 1909, the building rate for housing went on at a feverish pace, with one house being completed a day until the last of the 12 plans was completed in August 1913. Housing construction started on Highland Avenue and in the Logstown area on Baker, Iron, and Calhoun Streets. The last plan to be built was Plan 12.

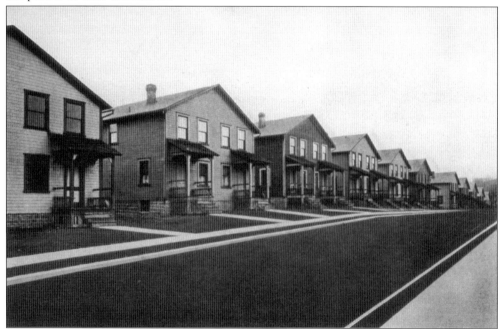

The two-family home was quite a popular option. Homes similar to these were in the Plan 7 neighborhood, the Logstown area, and others sites throughout the community. Between the years 1909 and 1913, 1,500 residences were built in the town.

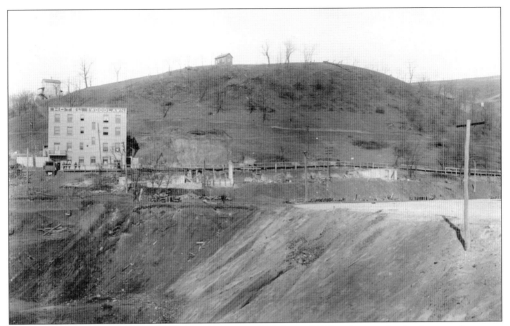

Hopewell and Sheffield Avenues with a view of McDonald Heights in the background appear April 15, 1910. The Hotel Woodlawn is featured in the left foreground; it would later be known as the Riverview Hotel. McDonald Heights was originally part of the McDonald Farm that was purchased by J&L.

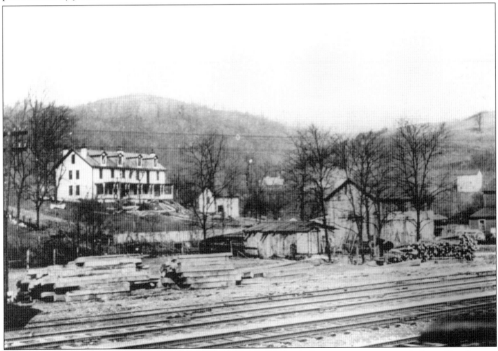

The large, multistory building, shown here in 1908 in the left center, was an early boardinghouse built by J&L for their employees. This particular boardinghouse was located on Kiehl Street. The freight yard of the P&LE Railroad can be seen in the foreground.

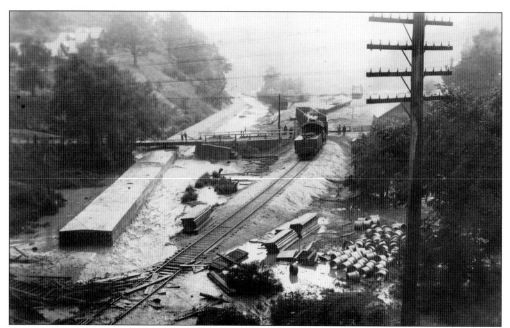

In this photograph, rushing floodwaters can be seen on both sides of the unfinished culvert overflowing the banks of Logstown Run. The culvert to contain the stream was under construction when the valley was flooded on June 26, 1909. Highland Avenue is visible in the above left. The railroad tracks were installed to support the construction of the culvert and businesses along Franklin and Sheffield Avenues.

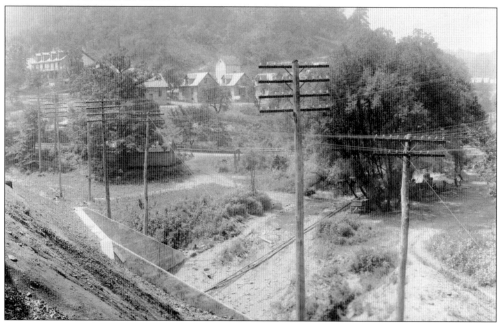

The area of Highland Avenue and Kiehl Street is shown in July 24, 1908. The multistory boardinghouse is located on Kiehl Street, and the residences are on Highland Avenue. The wooded hill in the above left would become Plan 6. The tunnel entrance leading to J&L is visible in the lower left.

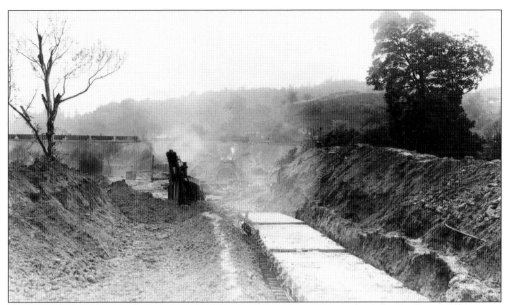

This photograph was taken from the area that would become Franklin Avenue at the WYE. This photograph is looking east towards the Ohio River. The P&LE steel trestle that was used to span Woodlawn Valley can be seen in the above left. The flat railcars featured in the center were used to deliver material to the construction areas.

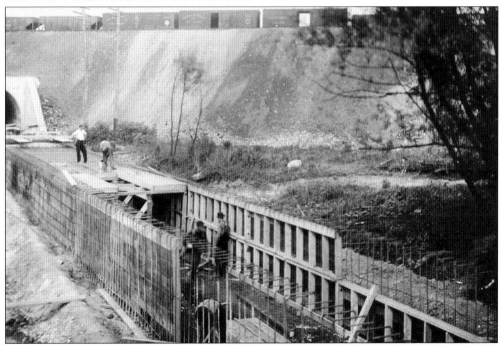

Before Franklin Avenue could be built, the stream that ran through the valley to the Ohio River had to be contained and controlled. A concrete tunnel was constructed from the Stone Arch at the western end of the valley to the railroad crossing at the eastern end. The culvert was large enough to accommodate mobile equipment. Tractors would enter the river end of the culvert to conduct routine cleaning and maintenance operations.

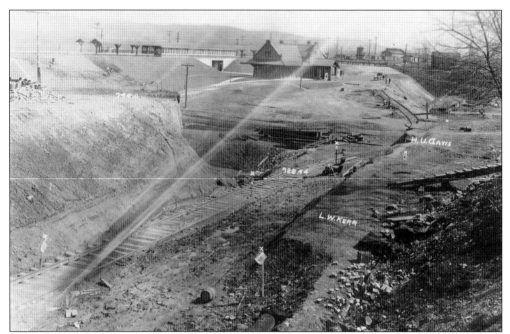

The new P&LE Passenger Station was completed in 1910 for the citizens of Woodlawn. The railroad track shown in the center was used for construction purposes and is located on what would become Station Street and Hopewell Avenue. The boarding platforms shown behind the station in the above center were accessed from a tunnel located beneath the tracks.

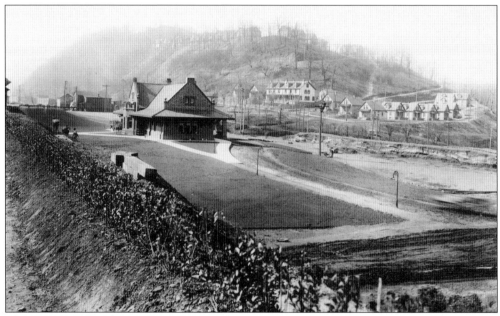

The P&LE Railroad station was opened for passenger traffic on April 15, 1910. One of the interesting features of the new station was the use of bilingual attendants to assist the foreign population with their transportation needs. The last passenger bought a ticket in the station on July 15, 1968. Eighty-one years after its opening, on April 26, 1990, the building was placed on the National Register of Historic Places.

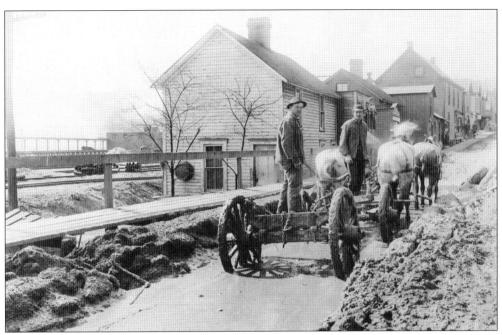

New roads were not always the answer to problem-free travel. The lack of paving on both streets and sidewalks is apparent in each of these photographs. During construction of the town in 1909, Woodlawn suffered from flooding conditions that were the result of heavy storms in the area. The photograph above shows Sheffield Avenue in the early stages of building the town. The P&LE freight station can be seen in the left center. The photograph below also shows Sheffield Avenue between Logstown and Woodlawn. The Woodlawn Hotel, later known as the Riverview Hotel, can be seen in the left center background.

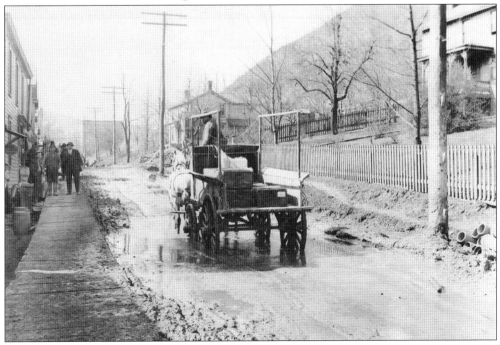

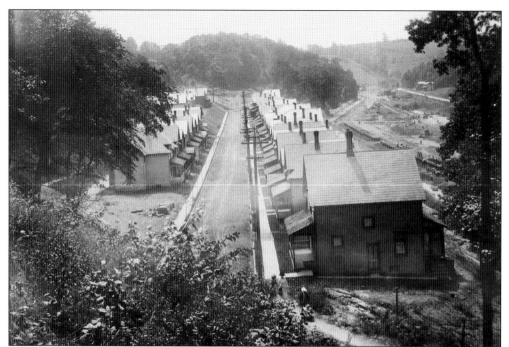

Highland Avenue was one of the first neighborhoods built by the Woodlawn Land Company. It was located on the hillside above Franklin Avenue and would become home to the skilled craftsmen who would build the mill. This area was known as Plan 5 of the planned community. This particular neighborhood was the location of a number of the early churches established in Woodlawn.

This is the east or river end of town on July 2, 1908. In the foreground, the homes on Highland Avenue are visible near the intersection with Kiehl Street. The valley at the bottom would become Franklin Avenue. J&L and the Woodlawn Land Company made a concerted effort to document the town's growth through photographs.

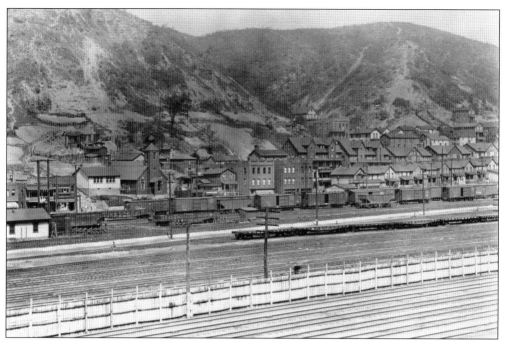

Featured in this 1933 photograph of Logstown, Plan 2, are several recognizable landmarks. The church on the left is the St. Elijah Serbian Orthodox Church on Hopewell Avenue. Zima Hall in the above center hosted dances, weddings, and ethnic celebrations. The second row of buildings, located on Calhoun Street, were 32-room boardinghouses. Special note should be made of the size of the railroad freight yard between the mill and Hopewell Avenue.

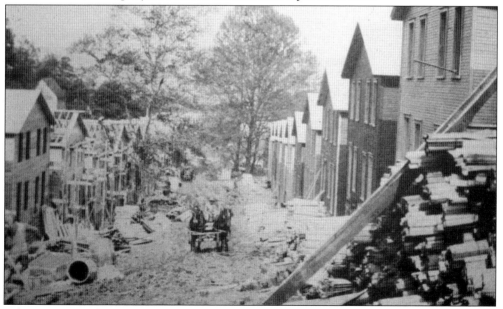

Baker Street, or Plan 1, was considered a part of Logstown. This plan was one of the first to be constructed by J&L exclusively for employee housing. Construction of frame homes in this area was started in 1907 and completed the same year. Some of the other streets in this neighborhood were Wilson, Hays, and Miller.

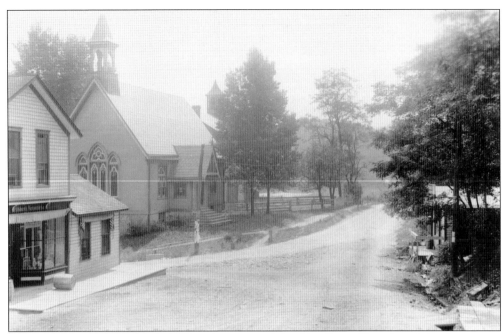

The Mount Carmel Presbyterian Church sponsored the Woodlawn Church and Academy as an outreach of their church in 1879. It served as one of the first school buildings for the town in 1909. The original Pittsburgh Mercantile store is visible to the left in the photograph. Different religious groups would utilize the academy building for services until their own churches were built.

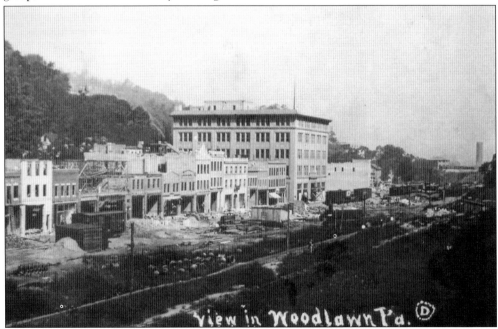

Pictured here is Franklin Avenue before the culvert was built to contain Logstown Run. The five-story, impressive structure is the new Pittsburgh Mercantile building. Established by J&L, it soon became known as the "company store." It was one of the first buildings constructed on Franklin Avenue. The other two were the LaGuillion Building and the Schwarz Building.

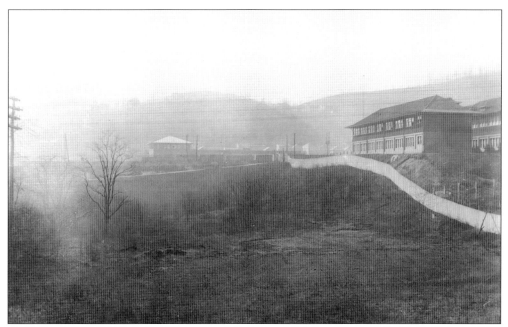

J&L's ongoing effort to provide recreational facilities for its employees and their families is evident here. The photograph above shows the location that J&L chose to build its first community swimming pool. The site is inside the tunnel on J&L property near the general office building, which can be seen in the above right portion. Note the hill in the above background of this photograph. This area would be developed into the Plan 7 section of the community. Pictured below on July 4, 1921, the pool is enjoyed by hundreds of the town's residents. It served as the public pool until the late 1920s when the community constructed three new pools away from the mill.

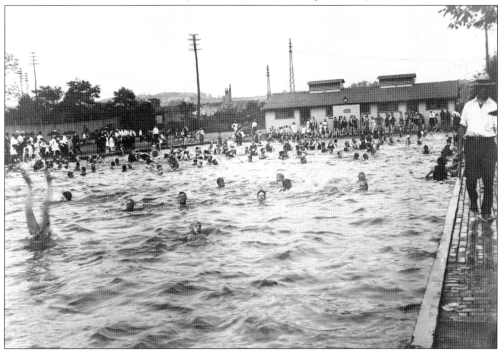

This photograph looks west across the future site of the B.F. Jones Memorial Library on April 30, 1922. By this time, Franklin Avenue was fully developed and paved with brick. The building in the above center is an Atlantic Gasoline station. The hill in the above right is the future location of the new high school.

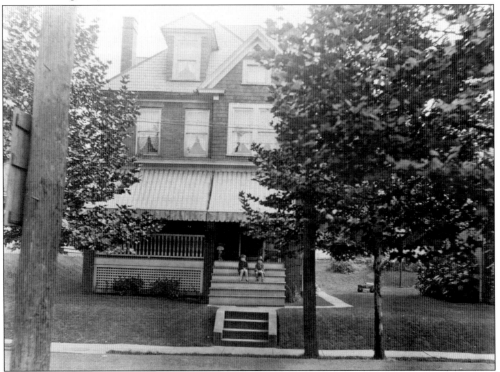

Isaac James and his family resided at 113 Shaw Street on September 25, 1925. Notice the well-kept lawn and beautiful trees. The streets were macadam, and the sidewalks were concrete. This area was known as Plan 6. Ultimately, Plan 6 would grow into three distinct neighborhoods known as First Hill, Second Hill, and Third Hill.

This home belonged to Jesse Wilkins of 307 Fourth Avenue, pictured September 29, 1925. Construction of houses on First, Second, and Third Avenues began in 1909 and was completed in 1910. Construction began on houses on Fourth, Fifth, and Sixth Avenues in 1906 but the houses were not ready for occupancy until 1913. This neighborhood was in the Plan 11 section.

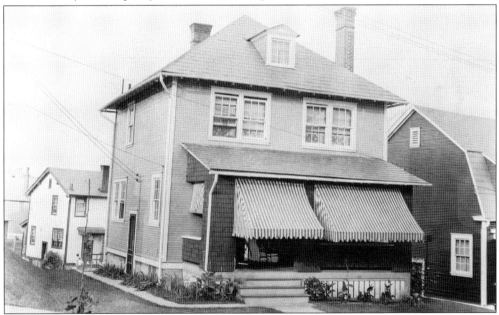

This pleasant home was the residence of Edward J. Bohn. This well kept home with flower gardens and a rocking chair on the front porch is pictured on September 29, 1925. The house was located in Plan 12. By 1913, the Woodlawn Land Company would have erected 378 single-family frame houses in Plan 12. These numbers do not include the Hall Farm development that was known as Hollywood.

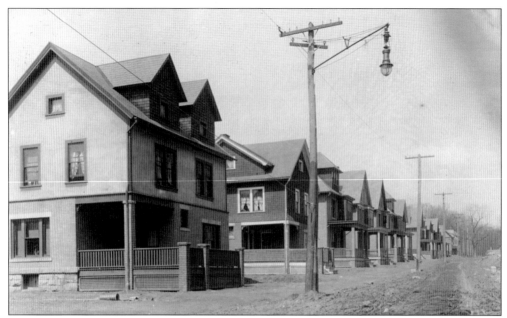

These homes located on Sheffield Avenue (Plan 8 in the original design of the town) are pictured on August 20, 1909. Home building continued in Plan 8 in 1910 and 1911. Streets developed during these years would be Orchard, Locust, Beech, and Walnut.

This dwelling is an example of the multifamily homes built throughout the town. This home was located at 143 Temple Street, and at the time of this photograph, September 28, 1925, was the residence of Edward M. Curry. Each building consisted of six side-by-side units with 16 units in total. The homes on Temple and Oliver Streets were built in 1912, and this neighborhood would become known as the "Bricks."

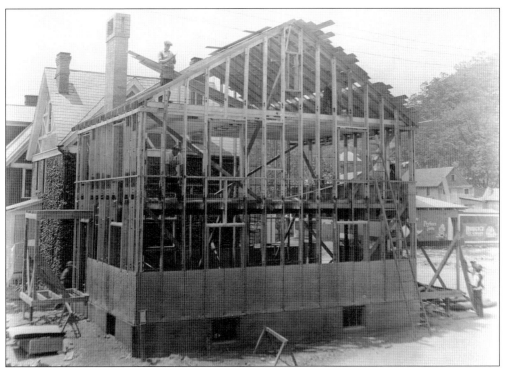

In 1926, J&L opened a mill at the Aliquippa plant that produced lightweight steel beams. Their marketing strategy to introduce and sell this new product was to advertise steel-frame homes as a smart alternative to wood framing. Not only did the mill produce the steel beams, but they also manufactured and supplied the "accessories" required to complete the construction of the building. Steel-frame homes were built throughout the Pittsburgh area and a number of other large, eastern cities. There were several steel-frame homes built in Aliquippa. These photographs feature one such home, built at the corner of Sheffield Avenue and Sheffield Road. The photograph above shows the steel frame being built and the below photograph shows the completed home. Note the sign advertising the steel-frame home.

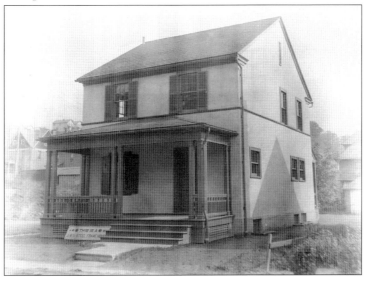

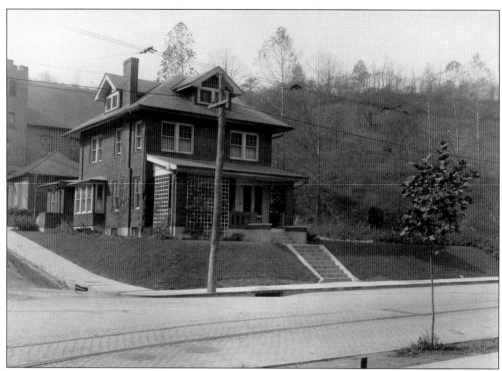

The city embraced progress, truly evident in these two photographs. The September 1925 photograph above features the home of Dr. J.A. Stevens, which was located at 909 Franklin Avenue. This was on the corner of Franklin Avenue and Main Street hill. In the late 1940s, The Bell Telephone Company purchased this beautiful home and property and razed it to provide a central location for construction of their planned telephone service building. Aliquippa High School is visible in the upper background of the photograph below.

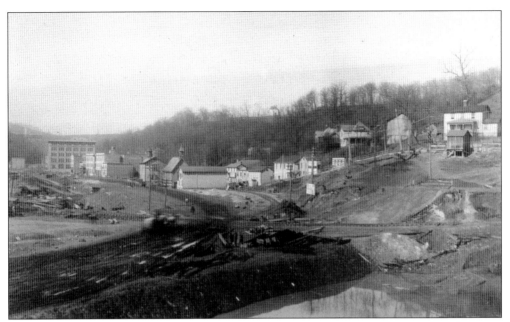

This is an early photograph of Franklin Avenue, looking west. Construction had already begun on a number of downtown buildings, the most prominent being the Pittsburgh Mercantile building in the left center. The Woodlawn Presbyterian Church and Academy can be seen in the center along with the original Pittsburgh Mercantile building.

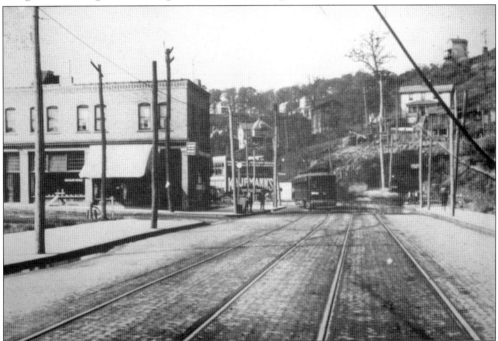

This photograph looks toward the city and away from the tunnel. Franklin Avenue was brick paved and contained two trolley tracks. Station Street is on the left, and Hopewell Avenue is to the right. The Woodlawn and Southern Street Railway Company provided transportation service throughout the community. One of their trolleys is visible in the center.

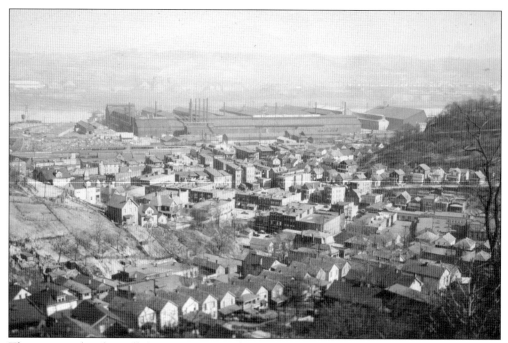

The mammoth tube mill departments are the focal point of this aerial shot and can be seen in the above center. Streets located in this area of town would be Station Street, Kiehl Street, Highland Avenue, Franklin Avenue, Sheffield Avenue, and Superior Avenue. This area was generally referred to as the WYE.

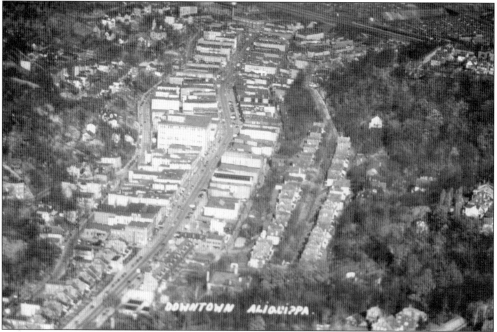

This is a dramatic view of downtown Aliquippa from the air. The business district lining both sides of Franklin Avenue is in the center. Highland Avenue is to the right of the center and on the far right is Plan 6. The above left corner shows Sheffield Avenue, Superior Avenue, and Plan 7.

Three

JONES AND LAUGHLIN STEEL COMPANY

The Jones and Laughlin Steel Company had a vision in 1900 that would spawn a community unique in its origin, makeup, and proud traditions. Not only did J&L construct a steel-making facility that was at the time the most advanced in the world, they also planned a community that would become a model for all industrial cities. Their plans called for affordable homes, a business district, all public utilities, a school system, a transportation network, and lighted and paved streets. The simultaneous construction of both plant and community began in 1906.

J&L began acquiring property in the Aliquippa and Woodlawn areas in 1898 and made public their intentions to build a steel plant in 1906. The foundation for the first blast furnace was laid in the spring of 1907 and the plant was functioning as a fully integrated mill by 1910. Construction continued at the site for a number of years adding additional iron making capacity, steel melting facilities, and finishing mills to satisfy the growing demand for steel products.

During the World War I years, the plant's production was almost exclusively committed to the war effort. A shell steel department was created to produce shrapnel steel, reportedly some of the best provided by any mill. More than 500 men from the plant served in World War I. Similarly, the World War II years saw an all-out commitment from J&L in support of the fight for the preservation of our rights and freedoms. In order to maintain production levels and commitments to the war effort, many of the operating jobs in the plant were staffed by women from 1942 through 1945.

At the height of steel manufacturing in Aliquippa, J&L employed in excess of 14,000 men and women, making it one of the largest, fully integrated steel plants in the world.

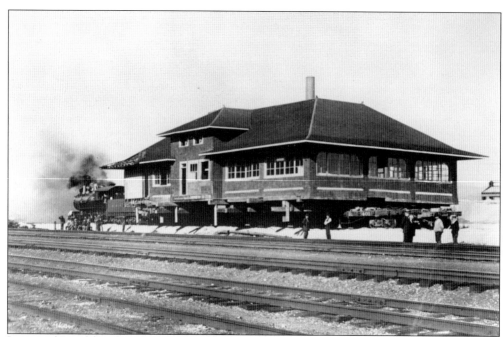

Jones and Laughlin chose an existing Aliquippa Park structure as their general office building. On June 8, 1908, the Aliquippa Park Dance Hall was moved via rail to a more central location about a mile away. The Aliquippa & Southern Railroad made the move with steam locomotives and flat cars.

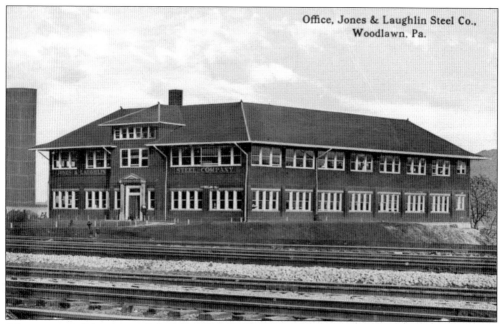

Office, Jones & Laughlin Steel Co., Woodlawn. Pa.

After a successful move and the construction of a ground floor, the Dance Hall assumed a new position as the second level of the beautiful new office complex of J&L. It would serve in the capacity of corporate offices until 1984. The building was razed in 1990.

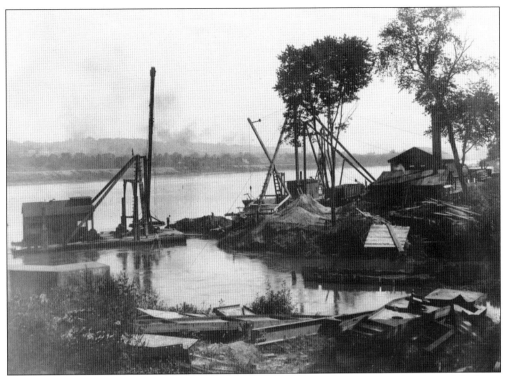

Construction of the steel plant was underway on July 10, 1907. To meet the plant's need for large amounts of water, the Central Pump House was built, which was located near the mouth of Logstown Run at the Ohio River.

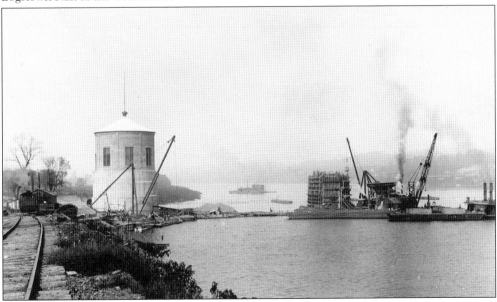

By September 15, 1908, the central pump house had taken shape, and the intake pier was well under way. The pump house was circular in design and was serviced by an overhead crane that traveled on a single, circular rail. This custom-designed, circular overhead crane was the only one known to exist at the time.

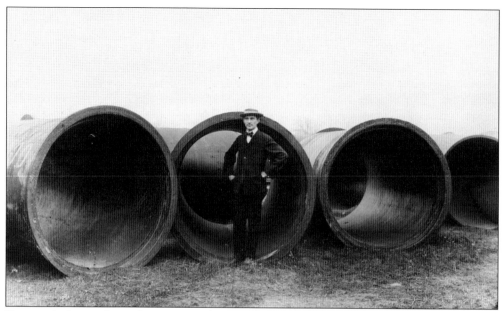

To move the large volume of water required, an equally large diameter pipe was needed. By comparison, the overwhelming size of the 60-inch-diameter pipe is pictured November 22, 1907.

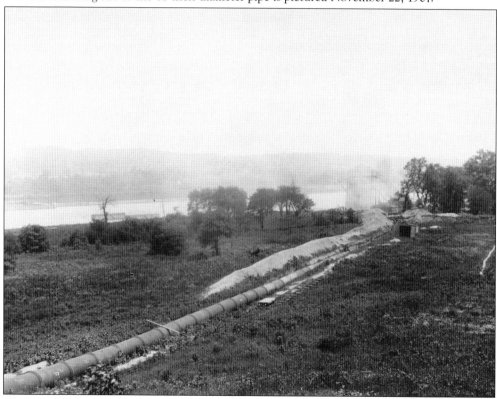

The Ohio River and the incomplete Central Pump House serve as a backdrop of the route and installation of the 60-inch water line, pictured June 20, 1908. This water line would travel about one quarter of a mile from the Central Pump House to the Blast Furnace Department.

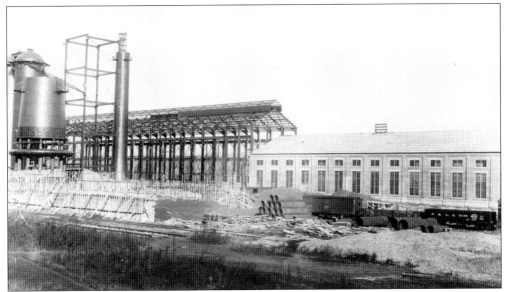

Construction continues to show progress with the North Mills Power House and the Blowing Engine Room. On the far left, an incomplete Blast Furnace can be seen on November 20, 1907. Note a Pittsburgh and Lake Erie Railroad gondola car in the lower right corner.

The west side of the Blast Furnace Department was the location of the ore yard and the equipment required to handle the raw materials used in the iron-making process. As late as November 20, 1907, the ornate carousel building from Aliquippa Park can still be seen in the upper left corner.

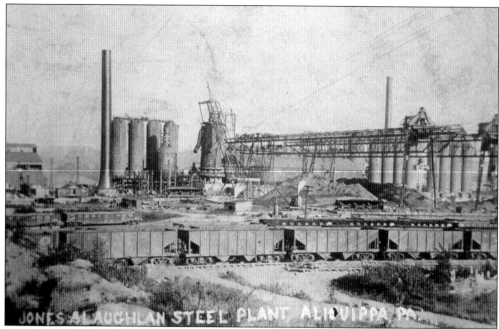

Construction of the blast furnaces was a large undertaking. Many blast furnace component structures can be seen here. Stoves, skip hoists, ore bridges, ore yard, railroad yard, rail cars, and the furnaces themselves are pictured in various stages of completion.

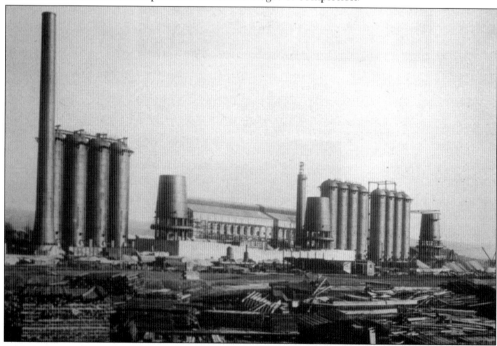

This is an unobstructed view of the construction progress on the blast furnaces and their accompanying stoves from the ore yard vantage point. The North Mills Power House and the Blowing Engine Room can be seen in the center background. The blast furnace produced molten iron, which was used in the steel-making process.

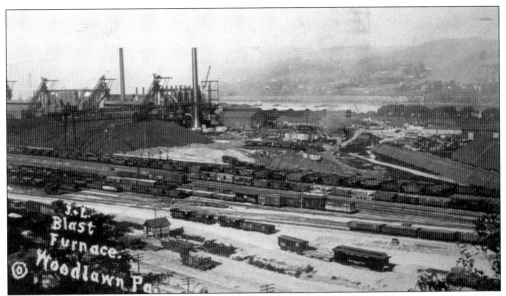

The left center of the image shows a well-stocked ore yard in front of three operating Blast Furnaces. The first blast furnace was blown in (put into operation) on December 1, 1909. The fifth and last blast furnace was blown in on December 5, 1919. Note the growth of the railroad yard in the center. This yard was used to handle all inbound raw materials and the shipment of all finished product.

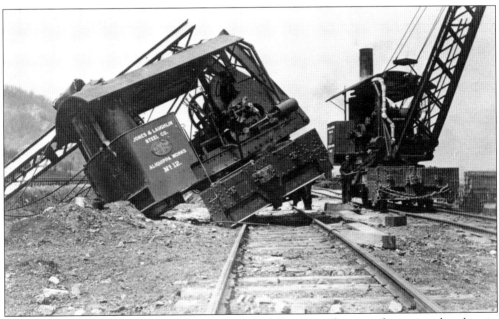

Mishaps are bound to occur during a construction project as large as the one undertaken in Aliquippa. The steam-powered rail crane, shown here, has left the rails and is in need of major repair work. The crane on the right is being positioned to help with the needed repairs.

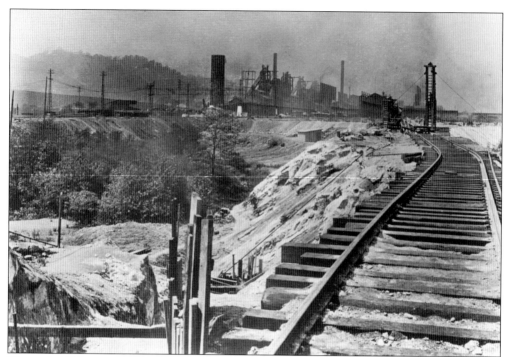

The early 1920s saw continued growth in the steel complex. The focal point of this photograph is the construction of the railroad trestle crossing Logstown Run and linking the North and South Mills with more streamlined, efficient rail service. Construction of the Fourteen Inch Rolling Mill can be seen in the upper right corner.

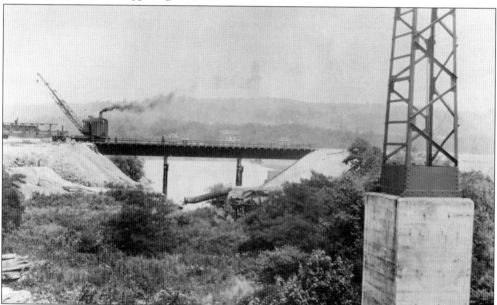

The completed railroad trestle over Logstown Run enabled the Aliquippa and Southern Railroad to serve the Aliquippa Works finishing mills with a route along the river and away from the congested ore yard side of the plant. The steam crane in the left center may have been the first equipment to cross the new bridge.

The Fourteen Inch Rolling Mill was a merchant mill producing a wide variety of structural steel shapes for the construction industry. The above photograph shows a test bar being torch cut from a red-hot angle section on the mill's hot bed. The Fourteen Inch Mill employee, shown in the photograph below, is checking the dimensional measurements on a hot-rolled angle section. The hot bed, as it was known in the mill, is in reality a cooling bed. It was 250 feet in length and served to reduce the temperature of hot-rolled steel from 1,500 degrees to about 200 degrees, so it could be straightened and cut to customer specifications. This department was first operational in 1926 and endured for 76 years.

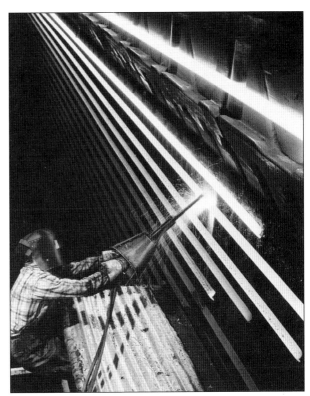

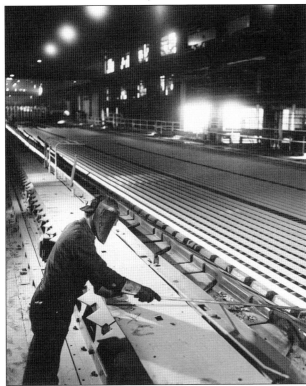

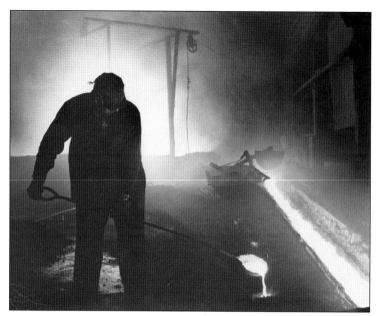

The Blast Furnace Department was one of the most intimidating and potentially dangerous places in the mill to work. The finished product was molten iron and the by-product was molten slag. These were 3,000-degree liquid products. Here, an employee is working on the cast house floor near an iron runner gathering a sample of iron for testing and chemical analysis.

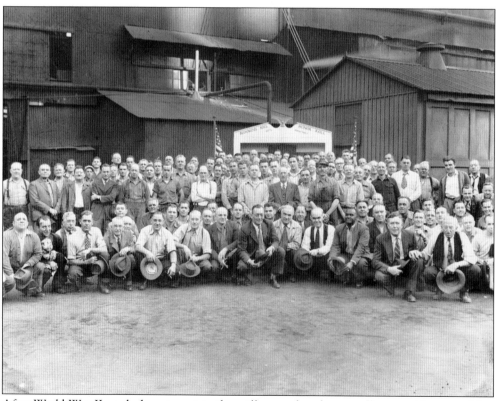

After World War II, each department in the mill erected an honor roll to provide recognition to those employees that had served their country. Every veteran was individually recognized with a gold-lettered, wooden plaque displaying his or her name. This group photograph is of the Blooming Mill veterans.

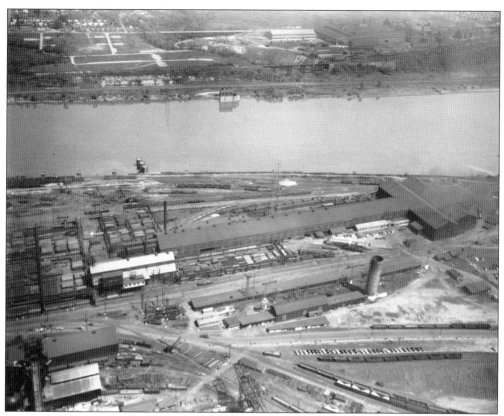

This aerial photograph features a number of North Mill facilities, in particular the Ten Inch Skelp Mill (white roof) and the Fourteen Inch Rolling Mill (T-shaped structure). The brick shed and the blast furnace standpipe are in the center below. The mill at the top right is A.M. Beyers, located across the Ohio River in Ambridge on Duss Avenue.

The Seamless Tube and Welded Tube Mills are shown in the above center of this image along the river. The Kiehl Street and Station Street areas of the community are below center. A recognizable structure in the lower left corner is the Pittsburgh and Lake Erie passenger station.

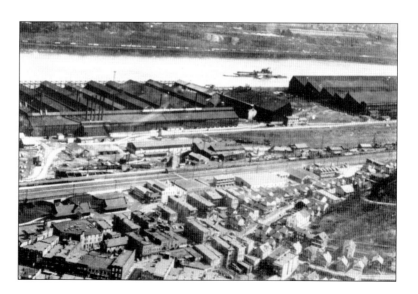

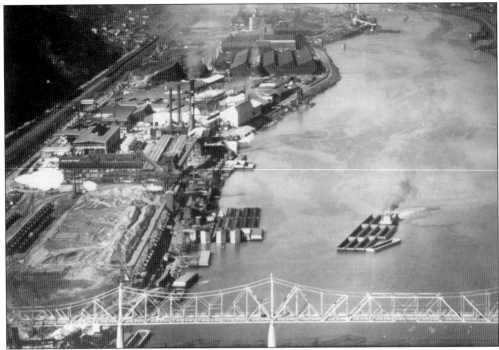

The South Mills Departments, featured here, consisted of the finishing mills and the coal handling and docks at the Aliquippa Works. The finishing mills were the pipe, rod and wire, nail, and tin plate mills. The vast coal handling and docks handled the coal requirements for the South Mills boiler house and can be seen in the lower left. The Aliquippa-Ambridge Bridge can be seen in the border below.

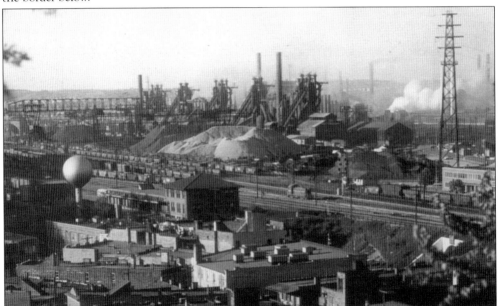

The five Blast Furnaces and the ore yard are the focal point of this photograph, which was taken across Kiehl Street and the WYE area. The Pittsburgh & Lake Erie freight station is situated in the left center, and the J&L general office complex can be seen at the far right.

50

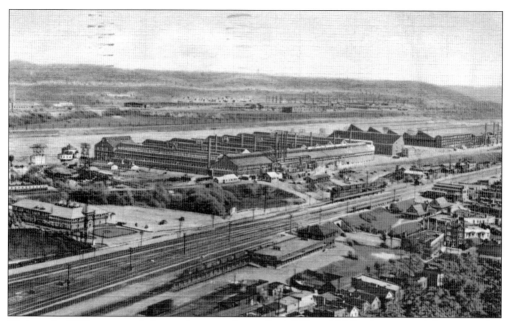

This early 1920s postcard shows the view from the McDonald Heights area of the city. This impressive vista shows the vastness of the South Mills area of the Works. The J&L main office is situated left center, and Hopewell Avenue is below center.

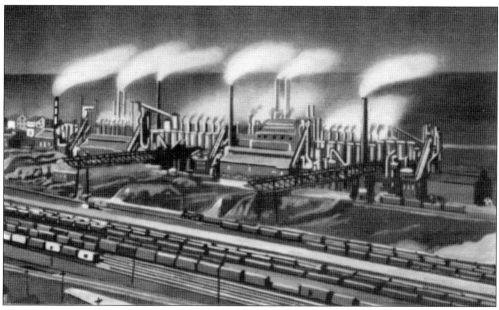

The Blast Furnace Department at night was truly an impressive sight. Fire, smoke, and steam meant work, jobs, and prosperity for the community. This c. 1935 postcard depicts a five blast furnace operation. The fifth and final furnace went into operation in 1919.

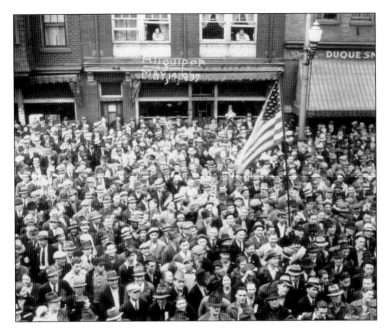

The history of organized labor in America can trace its roots to Aliquippa. The Wagner Act was declared constitutional by the Supreme Court in April 1937. J&L chose to test the act, which resulted in a three-day strike, culminating in a widely favorable vote to allow the Steel Workers Organizing Committee, SWOC, the right to organize the workers. Workers celebrate their victory on May 14, 1937, at the WYE.

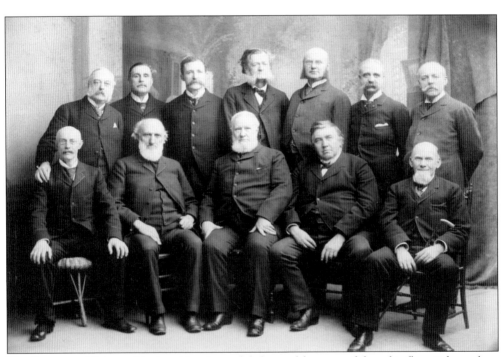

The Duquesne Club was Pittsburgh's private club for wealthy, powerful, and influential members of the business community. The "Number Six" luncheon group is shown here in 1892. This group of men composed the strength of the Pittsburgh's business and industrial sector. Benjamin Franklin Jones is seated in the center of the front row. His entrepreneurship and foresight built J&L, Aliquippa, and the steel industry of the 19th and 20th centuries.

Four

WEST ALIQUIPPA

West Aliquippa (Aliquippa at the turn of the 20th century) was a small, prosperous town. At the time, its southern neighbor, Woodlawn, was still a farming community. It had its beginning as a stop on the Pittsburgh & Lake Erie Railroad between Pittsburgh, Pennsylvania, and Youngstown, Ohio. The town was laid out in the early 1890s and was granted its own post office in October of 1892. With a population of over 600, it was incorporated as a borough on January 22, 1894.

There were several notable businesses, including Vulcan Forge, Mutual Union Brewing Company and the J.C. Russell Shovel Company. There was also a local amusement park that took its name from the rail stop for the town. The park operated for a quarter century before the property was sold to the Jones and Laughlin Steel Company for construction of their new mill. The town was quickly becoming a center of small businesses and industry, until J&L built their fully integrated steel plant just to the south. To accommodate the growing freight demands of this new mill, the P&LE expanded its railroad to a four-track main line that incorporated a large freight yard. This expansion by the P&LE virtually cut the town of Aliquippa off from access to a major highway. This resulted in the slow demise of the few industries in Aliquippa and precluded any future growth.

The town would be incorporated with its southern neighbor, Woodlawn, and the name Aliquippa would be adopted by both towns. When the incorporation of the two communities occurred, it created a problem for the P&LE. The name Woodlawn disappeared and became Aliquippa, leaving two adjacent rail stops with the same name. The original, smaller Aliquippa was west of the new, larger Aliquippa, on the railroad, so the P&LE changed the station stop to West Aliquippa. Problem solved, and West Aliquippa was born.

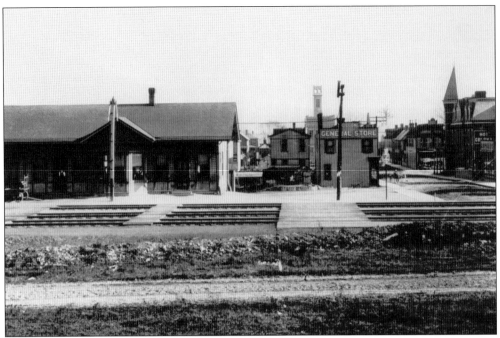

A few familiar sights in this 1908 West Aliquippa photograph are the P&LE train station on the left and Ciccone's General Store in the center. To the far right is the Hotel Columbia, whose proprietor was John Wiegle. The background center features the tower of the fire department building.

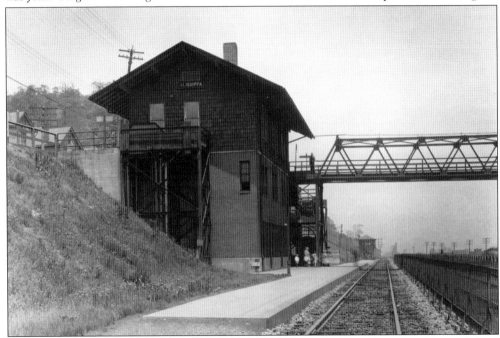

The P&LE, West Aliquippa (Aliquippa) train station is pictured here in 1918. This track level view shows the bridge connecting the depot with the boarding platforms. Entrance to the station was gained from the highway at ground level. The building along the tracks in the distance is the switch tower that controlled all of the rail traffic in the area.

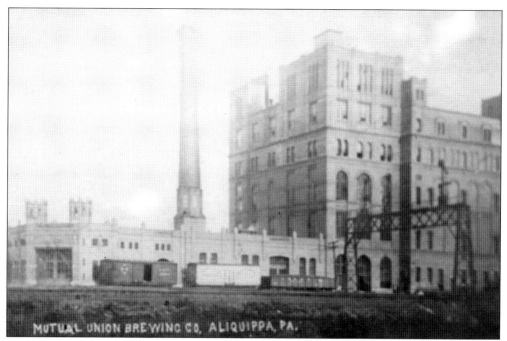

The Mutual Union Brewing Company was one of the larger employers in the community. It was established in 1905, and at the peak of its operations, the brewery had an annual capacity of 100,000 gallons of beer. Other businesses of note, not shown in this photograph, were the J.C. Russell Shovel Company, the Vulcan Crucible Steel Company, and the Kidd Drawn Steel Company.

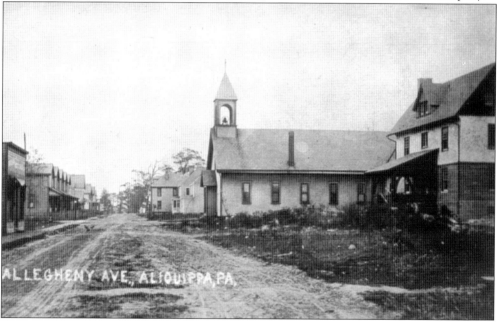

This is unpaved Allegheny Avenue in the early 1900s, looking north in the residential area of today's West Aliquippa. The church featured in the center is Saint Joseph Roman Catholic Church. Note the addition to the church had not been constructed, and the school had not been added.

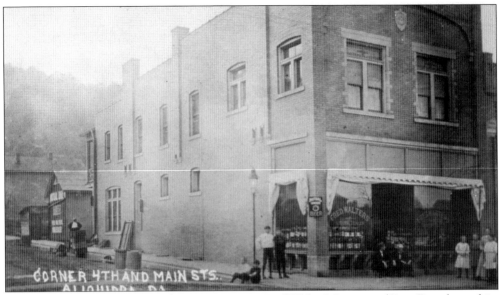

The corner of Fourth Street and Main Avenue was Fred Walter's Liquor and Beer Distributorship. This building served a number of businesses over time, one of which was Steinfeld's Hardware, founded by Jack Steinfeld. Its last owners were Milton and Virginia Steinfeld. Milton's brother, Jesse, would serve as surgeon general of the United States from 1969 to 1973.

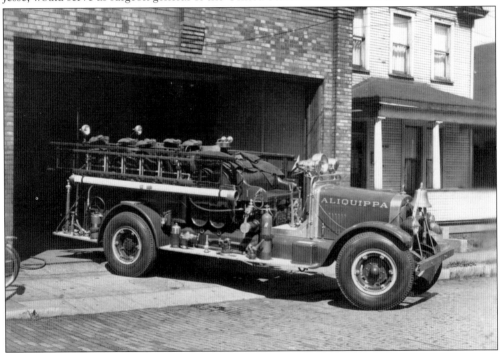

West Aliquippa's fire department was located at the corner of Third Street and Allegheny Avenue. The building was constructed in 1908 and the main floor supporting the weight of the fire equipment was made of wood. Note the brick-paved street. There were several brick factories located near Aliquippa specializing in the production of street bricks. These companies were in Fallston and Beaver Falls, Pennsylvania.

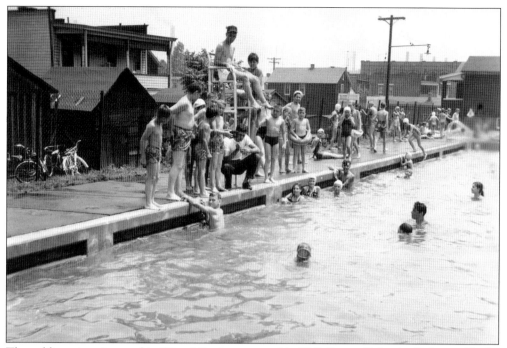

The public swimming pool in West Aliquippa opened in 1942. It was 40 feet by 90 feet and had a capacity of 170,000 gallons. Mickey Zernich is positioned under the lifeguard's chair in the center, taking water samples for evaluation and testing. He would become one of the community's more notable citizens, Dr. Michael Zernich.

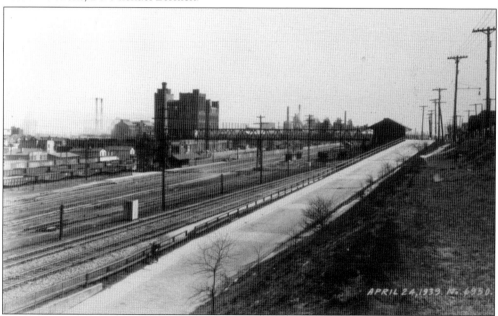

A southeastern view looks across the town on April 24, 1939. The center features the Mutual Union Brewing Company, and the right center shows the P&LE passenger station with the bridge connecting the station to the boarding platforms. The blast furnaces are visible in the distance. Note the vastness of the railroad freight yard between the highway and the town.

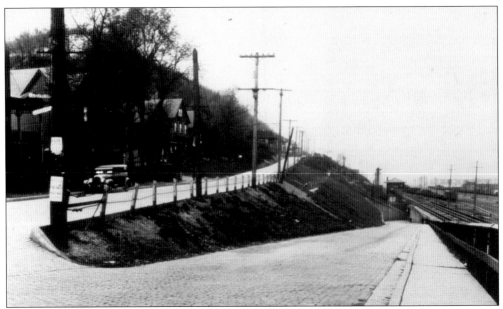

West Aliquippa was unique in all of America; it was recognized in Ripley's Believe It or Not as the only town in the United States with only one way in and one way out. This unique situation was the direct result of the growth and expansion of J&L and the P&LE railroad. In the early years, the railroad tracks could be safely crossed at wooden crossings, as there were only two or three sets of tracks. As the main line and freight yards grew, there was no safe way to cross into the town. This resulted in the construction of a tunnel under the railroad yard. The above photograph shows the exit from Hopewell Avenue onto the street that led to the tunnel entrance. The below photograph is looking from the tunnel entrance up to Hopewell Avenue. The building in the top center is the P&LE passenger station.

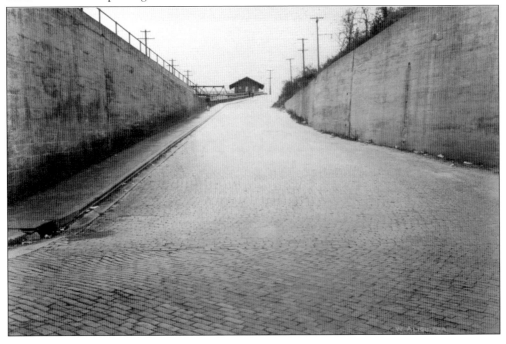

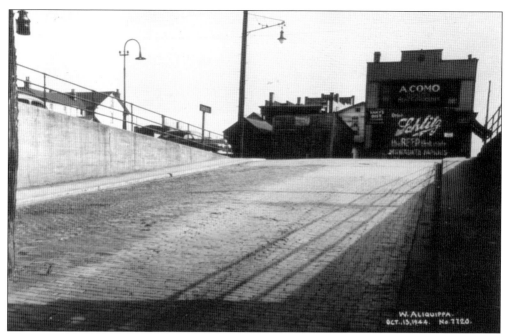

The growth and expansion of both J&L and the P&LE signaled the beginning of the decline of the industries in West Aliquippa. The tunnel entrance was convenient and easy for automobiles and small trucks, but the larger vehicles necessary for industry found it cumbersome. As the older businesses closed or relocated, prospective businesses showed little interest in a location that had a single way in and out and could offer no room for expansion. The tunnel was abandoned in favor of an overpass on April 14, 1964. This photograph is looking from the tunnel entrance up to the town on October 13, 1944. Visible in the above right corner is the A. Como building, sporting advertisements for Schlitz Beer and Yaky's Distributor. The photograph below looks at the tunnel from the town. On the right is the P&LE freight station, and in the above center is the city water storage tank.

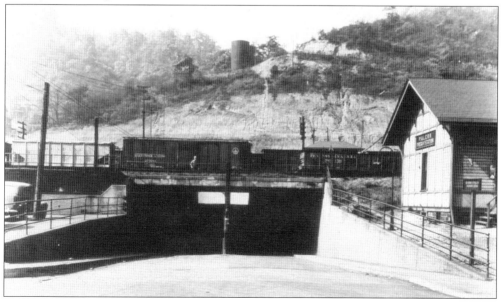

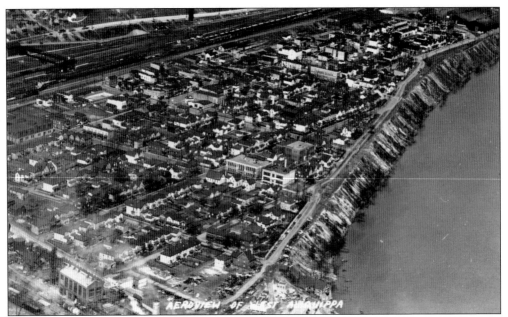

This postcard, featuring an aerial view of West Aliquippa, captures the expanse of the community and illustrates that the town was in fact surrounded. J&L's property ends in the below left corner and begins again in the above right. The P&LE Railroad's freight yard is in the above left, and the Ohio River is to the right.

There were two islands located in the Ohio River at West Aliquippa. The islands were strangely almost the same size and shape. The downriver island was Hog Island, and the southern or upriver island was Crow Island. This photograph features the southern end of Hog Island and the northern tip of Crow Island. In the below center, three slag ladles or thimble ladles that belonged to J&L are visible.

Crow Island served the residents of West Aliquippa and Aliquippa in numerous ways. There were recreational facilities such as baseball and football fields, truck gardening plots, and the Back River, which was a haven for fishing and trapping. During the winter months, the Back River would freeze over and become a perfect ice-skating rink. The photograph above shows Crow Island and the three barges that served as a bridge linking the island to the riverbank. The barges were equipped with a series of walkways and stairs that afforded safe egress to the island. The below photograph is a closer view of the barge and walkways on June 16, 1932. The garden plots on the northern end of the island are more obvious in this photograph. After 1929, J&L would gain ownership of both islands.

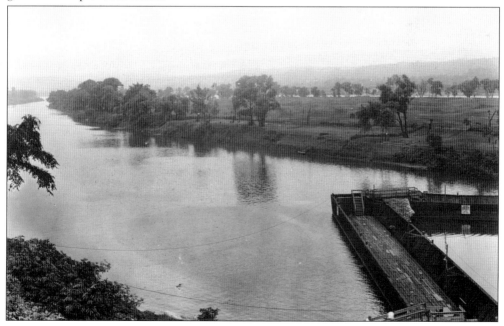

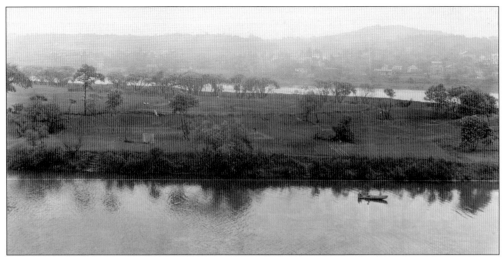

The most important contribution that Hog Island and Crow Island made to the communities of Aliquippa and West Aliquippa was truck gardening. The islands were ideally suited for growing crops of all sorts because of the rich, sandy soil found there. During the years of the Great Depression, J&L had the islands laid out in plots to be used by their employees and families as Liberty Gardens. Likewise, during World War II, the islands became the home of Victory Gardens, and a way for families to survive the very lean years that accompanied the war and the strict demands of rationing. The northern, or down river, end of Crow Island is pictured on June 16, 1932. A close look reveals many truck garden plots. The photograph below shows Plot "K" on August 1, 1932, and six unidentified residents proudly posing with their crops.

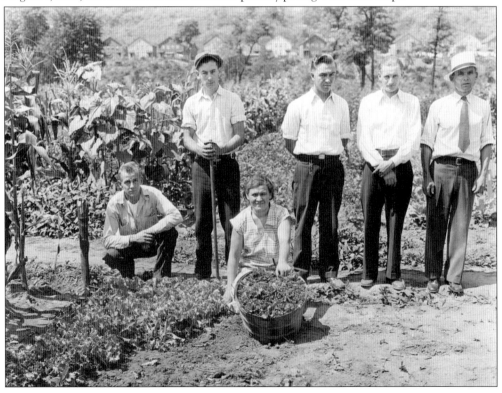

Five

CHURCHES AND SCHOOLS

Jones and Laughlin Steel Company believed that an educated workforce made for a quality workforce. The public school system was started in 1909, and instruction began in the fall of that year. Classes were held in various buildings in the town before the construction of the high school and elementary schools was complete. The educational system was considered advanced for the 20th century and always maintained a sound reputation. The vocational technical program at the high school was progressive for its time and served to prepare students to enter the mill with a working knowledge to help them succeed in their chosen occupations. The high school also offered an accredited college preparation course as well as a business course. Schools were a priority for the company as part of this new community, as is evidenced by the construction of seven elementary schools.

The churches of Woodlawn were as varied as the population. The few established churches in town were soon outnumbered by many different denominations as the influx of workers for the mill descended on the towns. At the end of the 19th century, there were a few Presbyterian churches and a Lutheran church established in the area. By 1924, there were over 24 different churches in the community.

These religions included Presbyterian, African Methodist Episcopal, Methodist, Baptist, Episcopal, Russian Orthodox, Greek Orthodox, Byzantine Catholic, Serbian Orthodox, and Roman Catholic, just to name a few. The immigrants brought their religious customs and beliefs with them to America, and their Church would serve as a comfort zone and a reminder of their European ancestry. Traditions formed by these Churches are still strong in the community today, and many former residents return home for the different festivals and celebrations of their native Churches. The people of Aliquippa are proud of their heritage, and these traditions have been passed on from generation to generation.

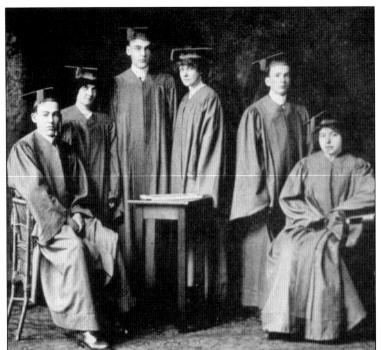

Pictured here are members of the class of 1913, the first graduating class of Woodlawn High School. The graduates are, in no particular order, Lehman Howard, Elvira Davis, Carol Howard, Eleanor Calhoun, Edwin Davis, and Ruth Scott. During the early years in Woodlawn, a number of buildings were used to hold classes, including the Woodlawn Academy building, which was located on Sheffield Avenue.

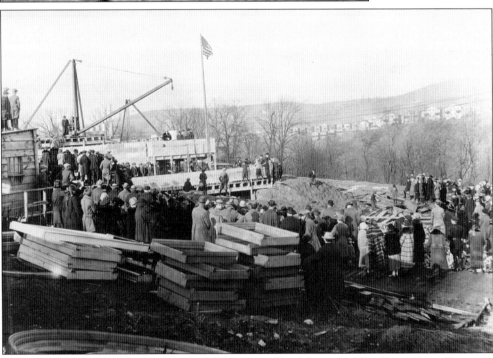

The Woodlawn School District purchased 20 acres of land from the Woodlawn Trust Company for construction of the planned high school building. This photograph shows the laying of the cornerstone on December 16, 1923. Construction was completed in 1925. The vantage point from the high school overlooked the city and many of its neighborhoods, including Plan 11 in the right center.

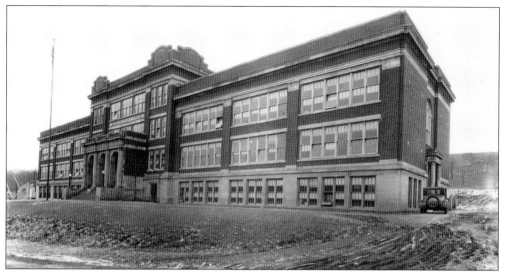

The original high school had 34 classrooms, a cafeteria, a vocational shop, a foods laboratory, and offices. This photograph shows the building during the 1929 expansion. Aliquippa High School was originally called Harding High School, in honor of Pres. Warren G. Harding. The school board voted to change the name to Aliquippa High School on December 22, 1930, to more closely identify it with the town's name change from Woodlawn to Aliquippa.

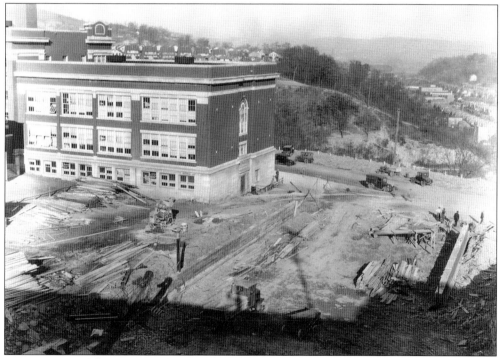

Construction of the annex had just commenced on November 6, 1928. The expansion would include classrooms and a new wing to accommodate the Home Economics curriculum. An athletic field would be built during the Great Depression as a Works Progress Administration (WPA) project and is still home to the famous "Aliquippa Quips." The high school's auditorium would be added in 1953.

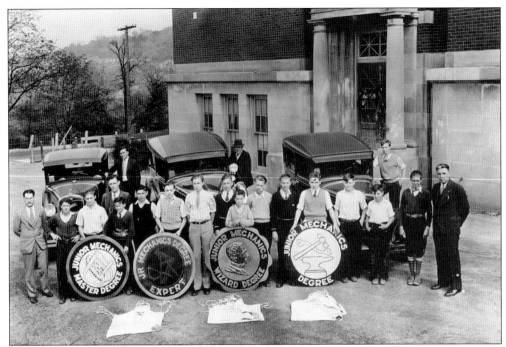

Aliquippa High School had one of the most progressive systems of education in the country. The students were offered vocational, business, and classical curriculums. The vocational course was designed to prepare young men for a career with J&L. It consisted of drafting, machine shop practice, electrical, woodworking, and automotive courses. Vocational graduates entered the mill well prepared for a long career. This photograph shows the Junior Mechanics Club on May 16, 1932.

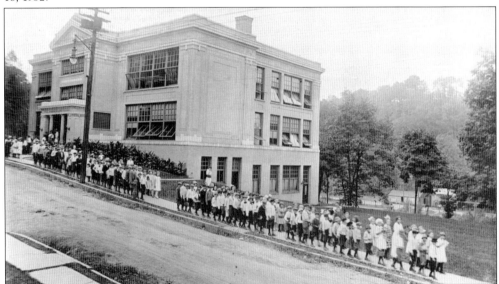

The first school building erected by the Woodlawn School District was the Highland School building. Construction began in 1909 and was finished by 1910. Highland School had 10 rooms and a basement and was the first fireproof building in Beaver County. It was initially intended to be the high school but never served in that capacity.

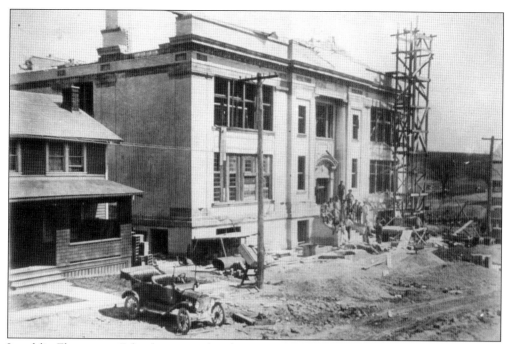

Laughlin Elementary School is pictured under construction in 1917. The cost of the building was $82,000, and when completed, had 12 classrooms. The school was named in honor of B.F. Jones's partner at Jones and Laughlin Steel Company, James B. Laughlin. This building still stands on Main Street.

Washington School in West Aliquippa was established long before the existence of the Woodlawn School District. In 1894, a two-story school building was erected at Fifth and River Avenues. The building, shown here, dates from 1914. A survey taken in 1930 showed 1,320 pupils enrolled: 531 Slavish, 381 Italian, 167 American, 75 Serbian, 58 Croatian, 30 Ukrainian, 21 Polish, 18 Hungarian, 16 Jewish, 9 Russian, 7 Lithuanian, 7 Austrian, and 2 German.

Jones Elementary School was located on Fifth Avenue in the Plan 11 community. It was built in 1919 at a cost of $87,795 and consisted of 12 classrooms. An addition was built in 1942 to accommodate the town's growing student population.

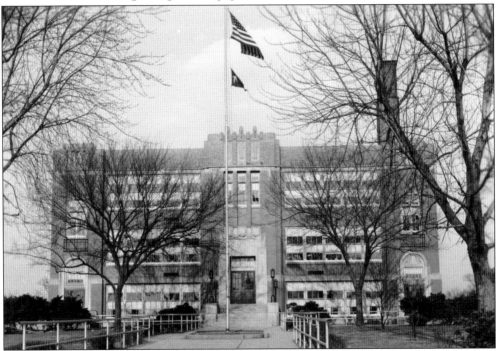

New Sheffield School was built on the Cooper Farm property and opened on May 7, 1931. The building was constructed of J&L Junior I-beams, a newly developed steel product of J&L. New Sheffield School would undergo a number of renovations and additions over the years. It still serves as the elementary school building for the Aliquippa School District.

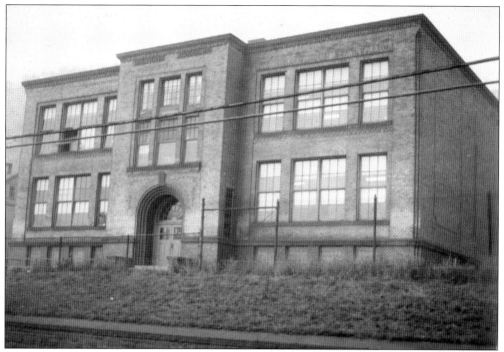

The original Logstown School building was erected in 1889 and served the children of Jones' Run and Upper Logstown. That early structure was razed and Logstown School, pictured here, was built to replace it. The school opened for classes on January 5, 1911. It consisted of eight rooms and was fireproof, similar to the Highland School building. There were eight teachers with 250 students enrolled on January 5, 1911. The school was razed in 1969.

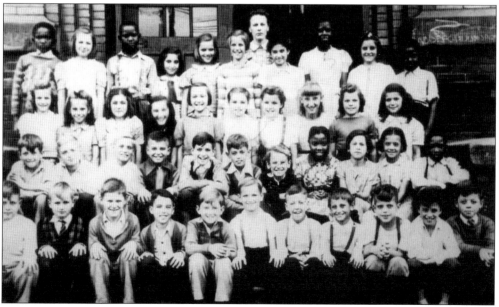

This 1939 class photograph was taken in front of Logstown School. A few students are identified, from left to right, (first row) John Yarosh, Carl Vukovich, Edward Vidmar, James Patton, Edward Stokes, and Steve Pontis. The school was located on Hopewell Avenue.

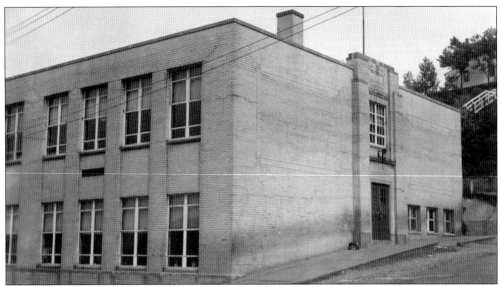

McDonald School, located on Superior Avenue, was built in 1940 with federal grant money. The cost of construction was $68,993, and the building featured six classrooms and a playroom. A census from 1954 indicated the student population at McDonald School of 175 ranging from kindergarten to sixth grade. There were six full-time teachers and four part-time teachers.

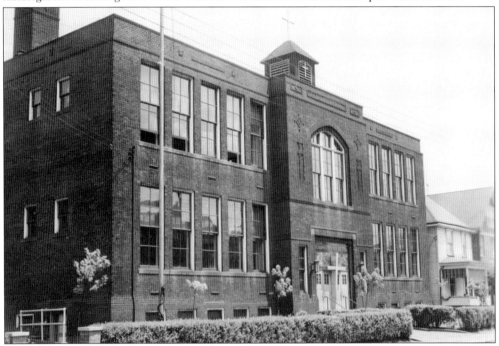

St. Joseph Roman Catholic Church in Aliquippa (present-day West Aliquippa) opened a parochial school in 1914. The school was staffed by Irish nuns of the Immaculate Heart order from Scranton, Pennsylvania. The original building served grades one through seven. In 1926, an addition of six rooms and an auditorium was completed to accommodate an eighth grade class. In the late 1940s, kindergarten and ninth grade were added. Roman Catholic education continued at St. Joseph's until 1968.

Mount Carmel was the first church in the Woodlawn area. It was established in 1793 in the area of town that was known as White Oak Flats. In 1814, a church was erected close to the present site of Mount Carmel Cemetery; however, in 1871, the congregation decided to move back to White Oak Flats. The frame building, shown here, served as the church until 1975. The present church was erected on the same site and was dedicated on October 3, 1976.

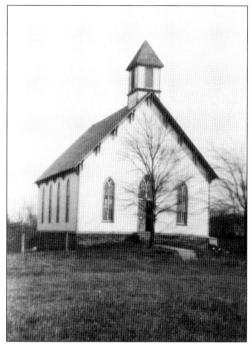

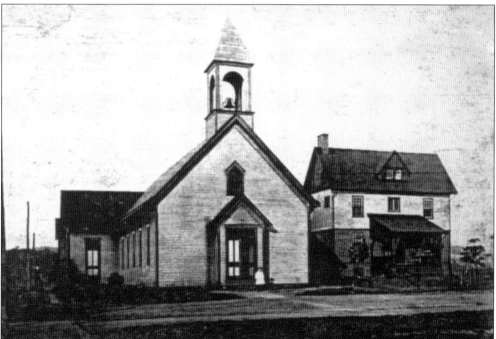

Pictured here is the original St. Joseph's Roman Catholic Church in West Aliquippa, which was founded in October 1894. St. Joseph's has an annual festival, which began in an unusual way. In the early 1920s, a statue of St. Anthony intended for St. Joseph's church was mistakenly delivered to the Sons of Italy club. The men of the club hoisted the statue to their shoulders and proceeded through the streets of town to the church. This procession is reenacted annually in West Aliquippa for the St. Anthony Festival.

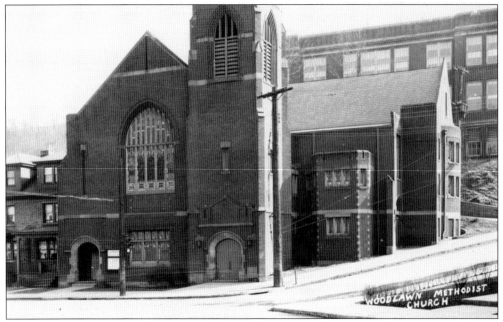

The First Methodist Church was granted a charter on September 4, 1911, and the first church was erected on property donated by J&L. The church pictured here was dedicated on June 27, 1926, and was located at 849 Franklin Avenue at the base of Main Street hill. This structure is no longer standing. The current First Methodist Church is located at the intersection of Brodhead and Chapel Roads.

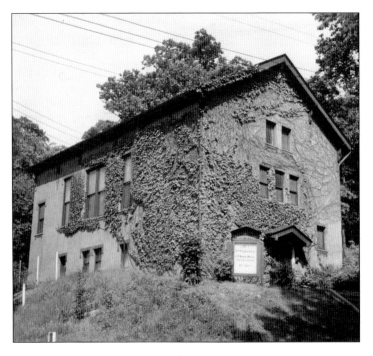

The First Baptist Church began as a missionary work of the Pittsburgh Baptist Association in the early 1900s, with the first services taking place in members' homes. A "summer church," which was a tent erected on property donated by J&L, was used during the summer months until the first church, pictured here, was dedicated on October 13, 1912. The congregation voted to expand in 1954, and a new church was erected at Twenty-first and McMinn Streets in the Plan 12 neighborhood.

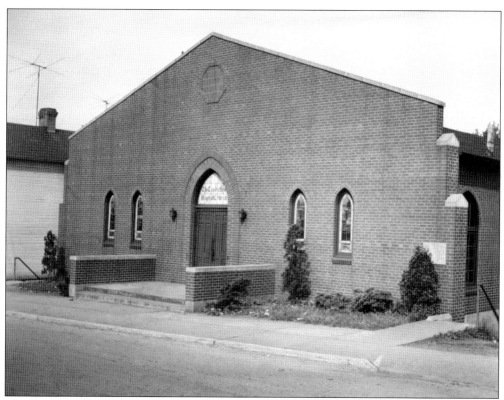

Triedstone Missionary Baptist Church is pictured here in 1945. Reverend Onley started this church in his home in the Logstown community on August 10, 1910. The first church building was located on Baker Street. The congregation purchased property at 505 Washington Street, in Plan 11, in 1919 and conducted services in the basement of this building until it was completed in 1945. It still serves the congregation today.

The Ebenezer African Methodist Episcopal Church was organized by Rev. N.D. Temple on July 25, 1924. Rev. Isaac S. Freeman was the first pastor to conduct services for the newly organized church. Early church services were held in the homes of the congregation and in various store locations until a permanent church was erected. The church shown here was erected at 1015 Davis Street in 1931 and serves the congregation today.

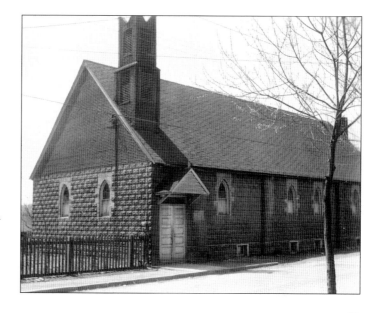

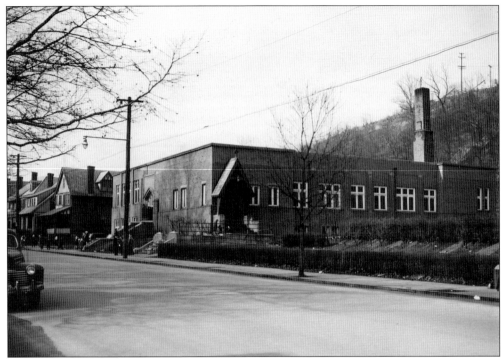

The original church structure of St. Titus Roman Catholic Church on Franklin Avenue is shown in this 1924 photograph. Prior to having this building, the first church services were held in the Woodlawn Trust Company building and a nickelodeon located on Sheffield Avenue. Father McGarey of St. Joseph Roman Catholic Church of Aliquippa petitioned Bishop Canevin to begin a mission in Woodlawn. As a result of the petition, Woodlawn was granted their own parish on February 6, 1911, the feast day of St. Titus.

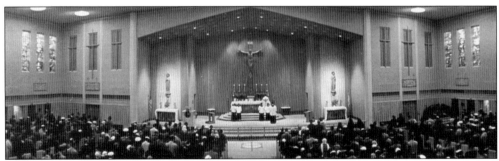

The congregation of St. Titus continued to expand, and plans were made in 1953 to build a new church. Ground was broken on November 28, 1954, and the new church was dedicated November 25, 1956. The church is an impressive contemporary design and features a magnificent stained glass window, which was the largest in the country when the church was constructed. St. Titus is still an active parish serving the community.

Woodlawn Presbyterian Church grew from a missionary effort of the Mount Carmel Church to serve the farming community of Woodlawn. A church and academy were built in 1898 on land donated by C.I. McDonald. By 1909, it became evident that a new location would be necessary as the area was quickly becoming the business district of the new town. Plans were made to build a new church, pictured here on Highland Avenue. The new church was dedicated on June 30, 1912.

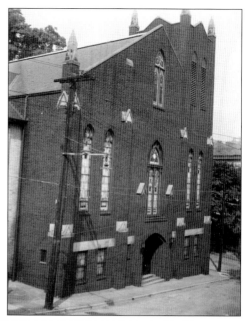

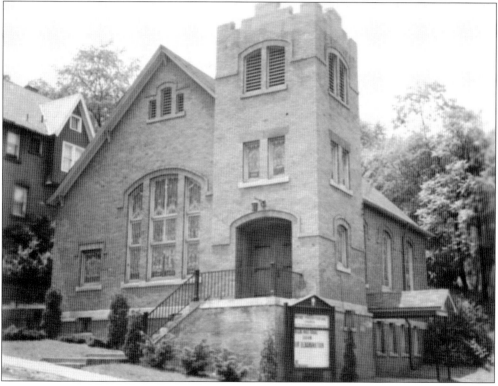

First United Presbyterian Church of Woodlawn conducted their first services on June 26, 1910 in the Woodlawn Academy building on Sheffield Road. Construction of the church pictured here was started in 1912 and completed in 1915 and was located on Main Street hill. The congregation voted to change the name to the First United Presbyterian Church of Aliquippa on May 26, 1929, to reflect the change in the city's name.

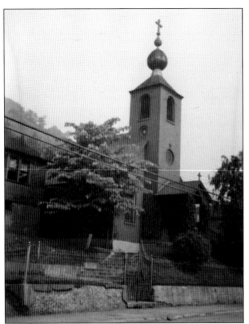

St. Elijah Serbian Orthodox Church was founded in 1907. J&L donated three lots on Hopewell Avenue to the congregation in 1912. A church building, purchased from the Presbyterians, was moved to this site in Logstown. After that building was destroyed by a storm in 1914, the church featured here was built and served the congregation until June 3, 1956, when the last liturgy was celebrated. The first liturgy of the current church, located at 2201 Main Street, was celebrated on June 10, 1956.

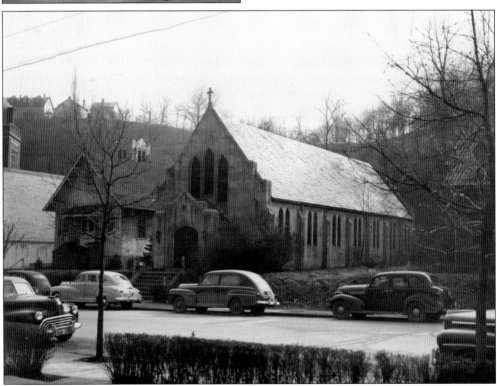

All Saints Episcopal Church began as a Sunday school in the home of Arthur Belden on October 10, 1915. Services were held in various locations in the town, primarily the Highland School building and the House of Prayer Lutheran Church, located in Logstown. Ground was broken for the church shown here on June 7, 1921, and the first service was held in the fall of that same year. All Saints' Episcopal Church was located at 921 Franklin Avenue.

Six

THE BUSINESS COMMUNITY

In order to support the wants and needs of the citizenry, J&L included in its plan a business community that would be, at its time, unequaled in the country. The town established first class fire and police departments, a transportation system, and even a municipal swimming pool. The city government was led by Burgess Art W. Combs, who was first elected in 1918.

The Pittsburgh Mercantile store was one of the first businesses in town. It was a company store where employees could purchase everything from groceries to home furnishings and charge their purchases to a personal account, which was satisfied through payroll deduction. Franklin Avenue became the business center of town, and soon, many retailers made for a beehive of activity. There were grocery stores, funeral parlors, automobile dealerships, barbershops, restaurants, movie theaters, clothing stores, and even a Harley-Davidson dealership. There were also a number of bars and social clubs located throughout the business district. Aliquippa was recognized in Ripley's Believe It or Not for having more bars along a one-mile stretch of street than any other city in America.

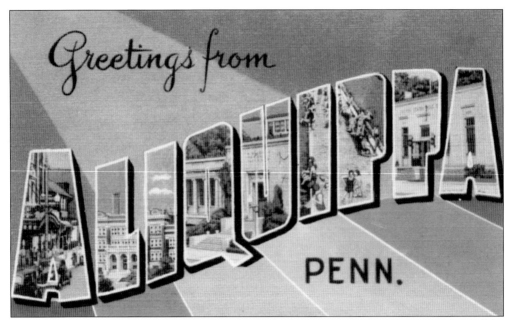

Postcards were a popular form of advertisement and communication for many years. One of the more popular styles of postcard was the large letter linen type, usually featuring cities and towns. Aliquippa was featured on one such card, and it is displayed in the photograph above. In the letters spelling out Aliquippa, you can see a few of the cities' many attractions. The State Theater, Aliquippa High School, Plan 12 pool, and B.F. Jones Memorial Library are partially visible in the letters. The top portion of the postcard below shows a few of Franklin Avenues businesses. The G.C. Murphy Company was a town favorite for years. The bottom portion of the postcard below shows the War Honor Roll, which was located along Franklin Avenue.

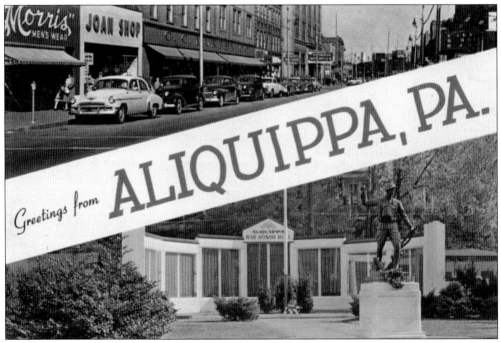

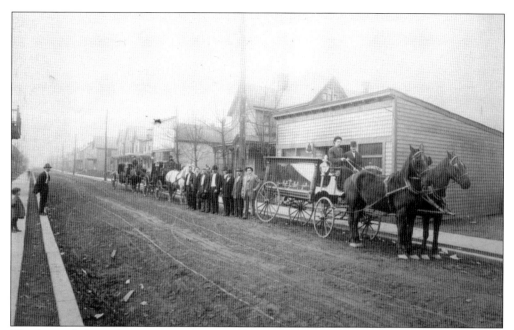

This hearse belonged to Hornstein's Funeral Home, located at 1013 Sheffield Avenue. Frank A. Hornstein established the first funeral home in Woodlawn/Aliquippa in 1906. Upon the death of Frank Hornstein in 1944, the business ceased operating for a period of time, in part due to World War II. The funeral home reopened in September 1951.

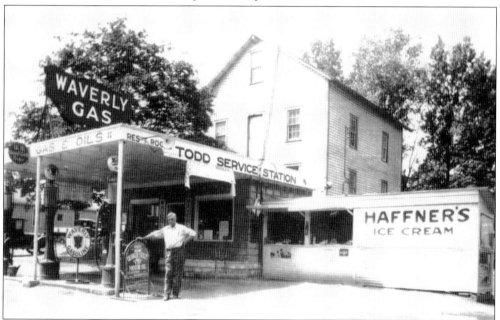

Todd's Service Station, pictured in the 1930s, was located at the intersection of Mill Street and Brodhead Road. It should be noted that Todd's featured Waverly gasoline and oil products as well as Quaker State Motor Oil. Waverly was a Pittsburgh-based oil company. Mill Street was so named for the gristmill that stood at this same location, dating from the 1880s. The gristmill is the building directly behind the gas station.

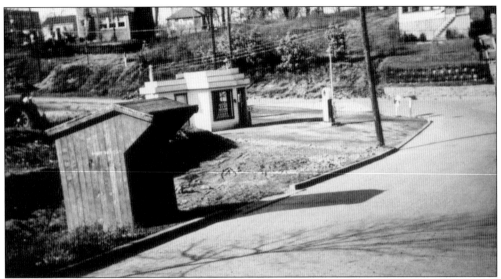

The corner of Twentieth Street and Sheffield Road was occupied by Sutton's gas station for many years. The station building itself was small in structure and the service rack was located on the outside of the building. In the left foreground is an open front wooden structure that served as a bus "shanty." These structures were built along the route of the Woodlawn and Southern Bus Company and served as weather protective shelters for the riders.

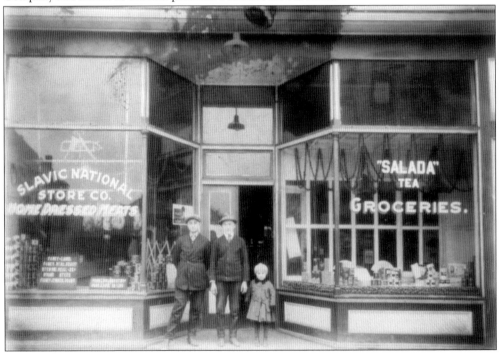

The immigrant population of Aliquippa relied on ethnic grocers, such as the Slavic National Store, for the exotic foodstuffs not readily available in Aliquippa's markets. Other grocery stores serving the foreign population were the Pan American Market on Kiehl Street and the Italian Wholesale Grocery located at 106 Hopewell Avenue. This melting pot of a city created a unique business opportunity for many grocers.

The Logstown Milk Company truck was a familiar sight in town. Aliquippa residents were accustomed to having their dairy products delivered fresh to their doorsteps several times a week. Some of the other dairies in the area were the Aliquippa Dairy located in West Aliquippa, Durr's Family Dairy, the Drinkmore Dairy, the John Habazin Dairy, Steuers Dairy, and the Sutherland Dairy.

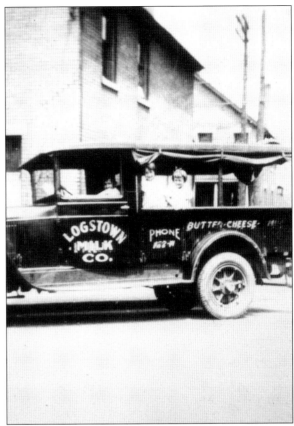

The Pittsburgh Mercantile store was established in Woodlawn by J&L to serve the needs of their employees. The original store was a small frame building located on Sheffield Avenue next to the Woodlawn Academy. This five-story structure was one of the first to be constructed on Franklin Avenue. It was a first class department store featuring all types of merchandise from food to furniture.

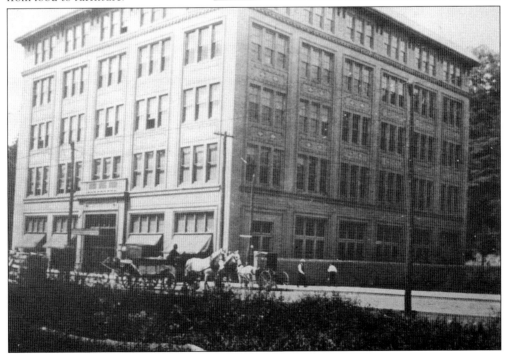

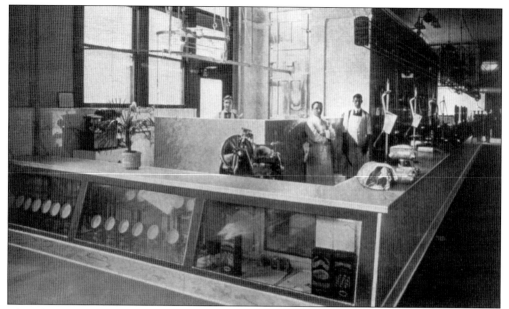

This photograph shows the meat and fish department of the Pittsburgh Mercantile store. The store had an extensive grocery department featuring fresh produce, meat, fish, and poultry and every kind of dry good imaginable. The store provided merchandise, service, and variety equaling any of the big-city department stores, such as New York City's Macy's and Gimbels or Pittsburgh's Kaufmanns and Hornes.

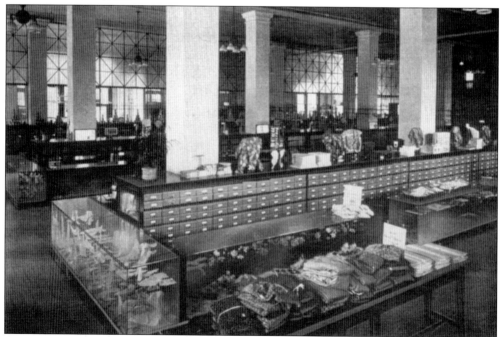

The Pittsburgh Mercantile Company store featured top-quality merchandise. Displayed here is the woman's accessory department. All types of merchandise were available, including an entire department for Boy Scout and Girl Scout uniforms and supplies. The highlight of the year was the Christmas season, when the toy department and Santa Claus delighted the local children.

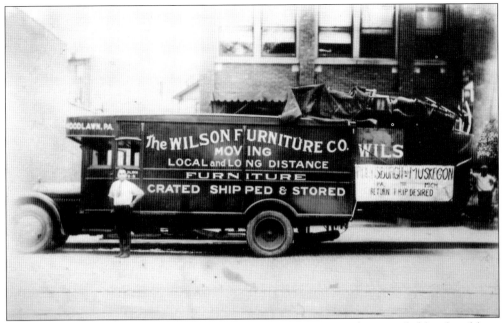

In addition to selling furniture, The Wilson Furniture Company also provided local and long distance moving services. This photograph shows the Wilson furniture truck loaded for a trip to Muskegon, Michigan, and advertising for a return haul to Woodlawn. The Wilson Furniture store was located at 224 Franklin Avenue.

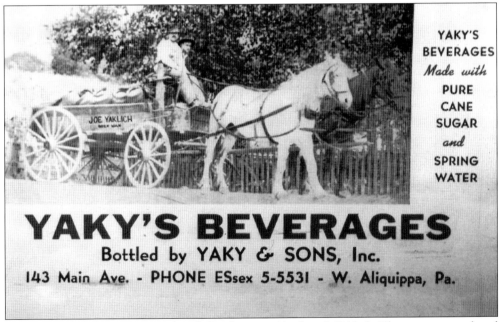

Yaky's Beverages was a company founded and operated by Joseph Yaklich. The company produced and bottled soft drinks. At the time of this photograph, the business was located in West Aliquippa at 209 Main Avenue. In the early 1960s, Yaky's would relocate to Kennedy Boulevard in Aliquippa. Every child growing up in Aliquippa enjoyed Yaky's "pop" in all of their favorite flavors, like cherry, orange, root beer, cream soda, grape, and lemon-lime.

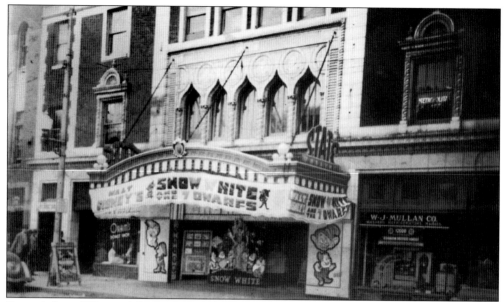

Disney's *Snow White and the Seven Dwarfs* was playing at the State Theater on Franklin Avenue about 1939. Local artist, Pete Dobish, painted the advertisements featuring the Seven Dwarfs in the front of the theater. Dobish was a talented artist with a business that served the sign and poster needs of J&L for many years. Aliquippa had three movie theaters during this era, the other two being the Strand and the Temple also located on Franklin Avenue.

One of the cities prominent physicians, Dr. Harry Bradford Jones's office was located in this house at 450 Highland Avenue, pictured September 28, 1925. He would later relocate to Franklin Avenue. His son, Dr. H.B. Jones Jr. also served the community for many years as a physician.

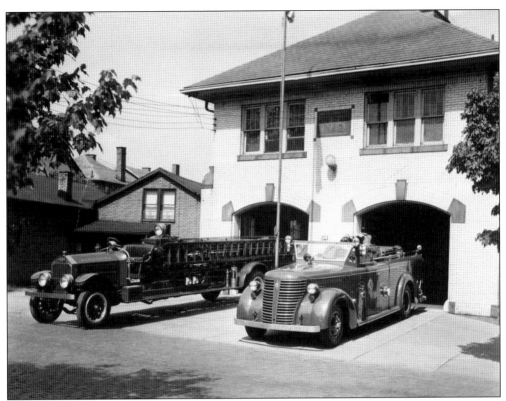

Woodlawn had two fire stations to serve the community. One was located on Franklin Avenue in the Municipal Building; the station featured here was located on Meadow Street in the Plan 12 area of town. The fire trucks in this photograph were an all-purpose cities service truck and a 750-gallon pumper truck.

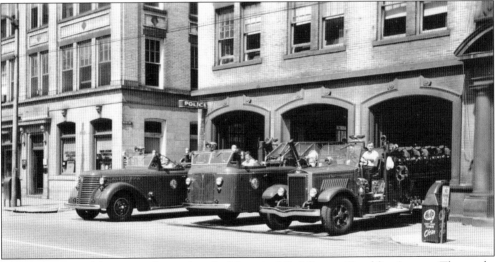

This is the central fire station located in the Municipal Building on Franklin Avenue. The trucks featured here are, from left to right, a Mack truck with a 1,000-gallon pumper, an American La France with a 750-gallon pumper, and an American La France ladder truck with 65-foot aerial ladder and a 250-foot wooden ladder.

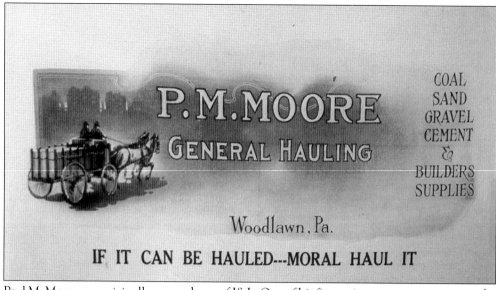

P.M.MOORE

GENERAL HAULING

COAL
SAND
GRAVEL
CEMENT
&
BUILDERS
SUPPLIES

Woodlawn, Pa.

IF IT CAN BE HAULED---MORAL HAUL IT

Paul M. Moore was originally an employee of J&L. One of his first assignments was to oversee the early stages of construction of the mill in Woodlawn. In 1912, Moore negotiated an agreement with J&L to purchase all of their horses, wagons, and related equipment in exchange for providing all of the hauling services required by the mill and community. He left J&L's employment in 1912 and established the P.M. Moore Co., which served the city for over 75 years.

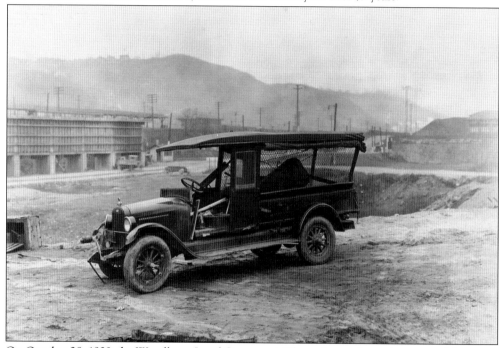

On October 28, 1929, the Woodlawn Land Company's Chevrolet truck was in a state of disrepair. Note the structure at the left center, which is the P.M. Moore tipple. Each segment of the tipple contained a different commodity that was delivered by railcars into the top of the tipple then dispensed into trucks from the bottom. Sand, gravel, coal, and limestone were some of the items handled here.

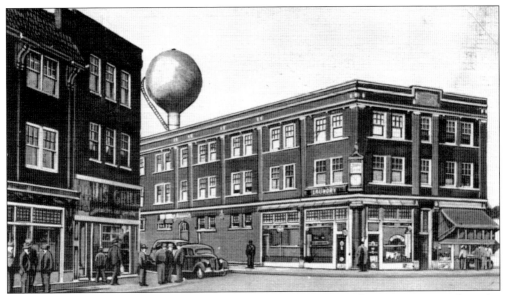

This postcard shows the area of town where Franklin and Hopewell Avenues met to form the letter "Y." This area is still known today as the WYE, even though the configuration changed in the early 1960s with the rerouting of Constitution Boulevard, the removal of a number of homes and businesses, and the addition of an overpass. The city water storage tower can be seen in the background, along with the Joseph Building to the right.

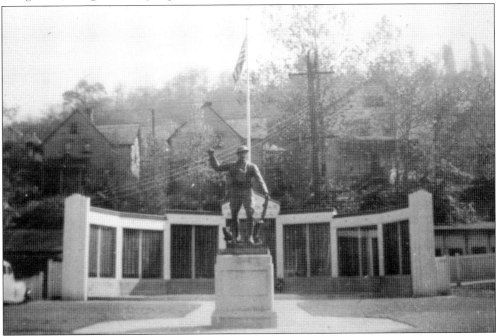

The Aliquippa War Honor Roll was originally located on Franklin Avenue adjacent to the post office. The original War Honor Roll was dedicated on May 31, 1944. This doughboy was located on the Aliquippa side of the Aliquippa-Ambridge Bridge with a similar doughboy located on the Ambridge side. When the communities constructed their war memorials, the doughboys were relocated from the ends of the bridge to their respective Honor Rolls. Both are still standing today.

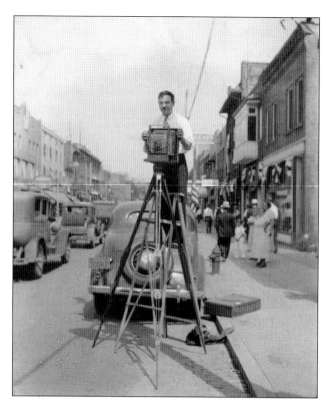

Emanuel Simantiras can be seen above, capturing an event on Franklin Avenue. This pose was a common sight in Aliquippa as he photographed most of the town's important events, along with the usual photographic fare, such as weddings, graduations, and family and children portraits. He was so popular in Aliquippa that residents called everyone Simantiras if they had a camera in hand. He moved his business from Wylie Avenue in Pittsburgh in the 1930s. The photograph below features Simantiras holding his son, Stanley, in front of his studio at 333 Franklin Avenue in 1936. Samples of his work can be seen in the front window of his studio. (Courtesy of Stanley Simantiras.)

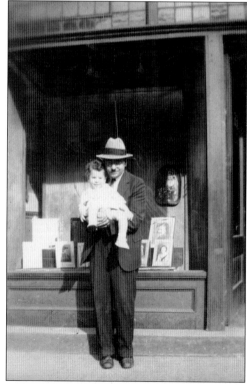

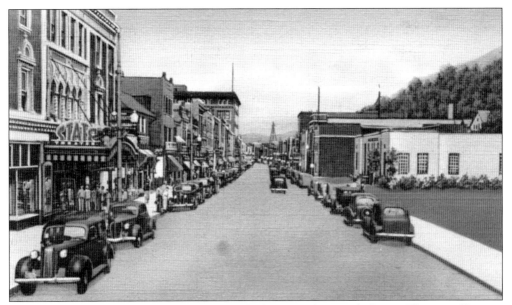

This late 1930s postcard is of Franklin Avenue looking east from Engle Street. The post office was new, the trolley tracks had been removed from Franklin Avenue, and there is a line of spectators preparing to buy a ticket at the State Theater ticket office.

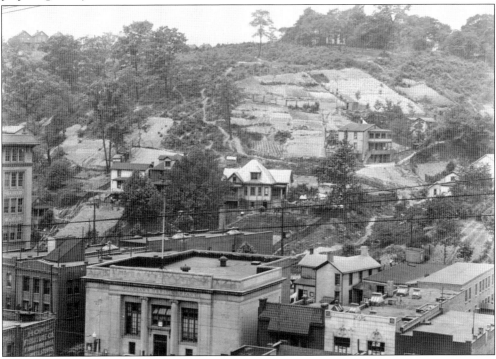

This photograph looks across Franklin Avenue at the hillside along Sheffield Avenue June 16, 1932. The Woodlawn Trust Building is shown in the below center. Woodlawn Trust was a locally owned bank founded in the early days of Woodlawn by a group of local investors headed by P.M. Moore. The bank would ultimately have two additional branches in the community. Note the Liberty Gardens in the above center.

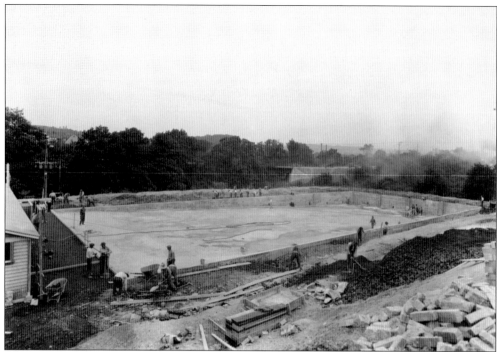

Aliquippa had three municipal swimming pools. One was located in the Plan 11 neighborhood, one in West Aliquippa, and the one pictured here on Main Street in the Plan 12 community. J&L initially constructed a public swimming pool in the early 1900s on mill property adjacent to the general office complex. It served the community during the early years and fell victim to the expansion of the mill. This photograph shows construction of Plan 12 pool on June 28, 1928. The bridge in the center was built to cross a ravine and was known as the Hollywood bridge. The postcard below depicts the Plan 12 pool during the 1940s.

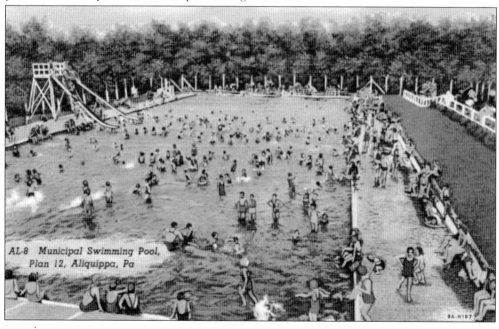

AL-8 Municipal Swimming Pool,
Plan 12, Aliquippa, Pa

90

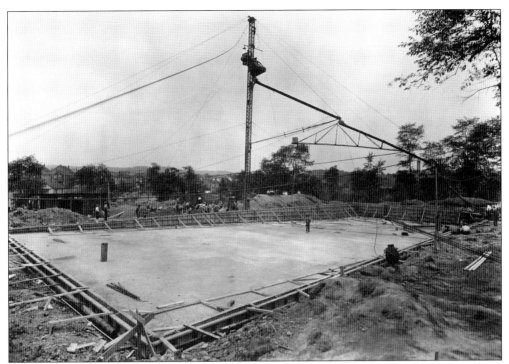

Plan 11 pool was built soon after the Plan 12 pool. The above photograph shows the construction site on June 7, 1929. The large crane in the center was used to move concrete from a central area to the formed walls via a series of gravity conveyors. Plan 11 homes are visible in the left center. The photograph below shows the finished product on dedication day. The pool was officially opened to the public on June 24, 1929. In the above left corner of the below photograph is the smoke stack at the city's incinerator.

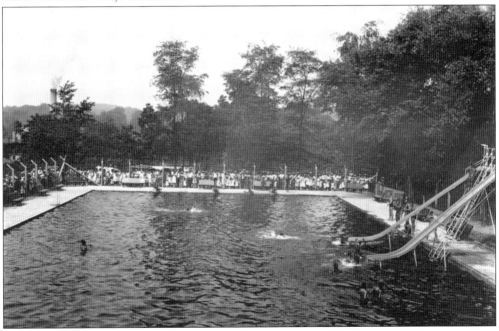

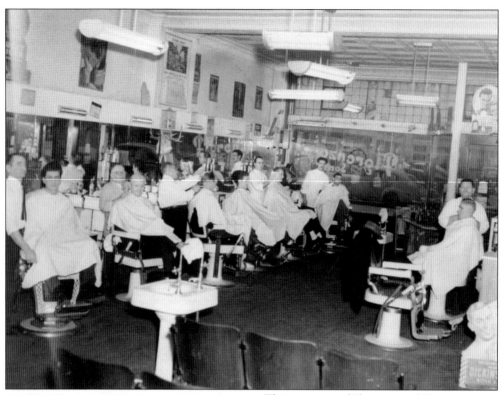

This is a view of Florenzo and Sons Barber Shop in 1942, which was located at 253 Franklin Avenue. The name of the business can be seen on the plate glass window. The barbers in the photograph are, from left to right, Mr. George, Mr. Tish, unidentified, Ed Skiba, Dino Guerrieri, one of the owner's sons, and Florenzo Guerrieri, family patriarch and founder of the shop. The other son, John, took the photograph. (Courtesy of Johneen Latone.)

The man on horseback is Joseph Latone, owner of Joe's Riding Stable, pictured in 1946. The young man inside the stable in the background is his grandson, Butch Latone. The riding stable was located on Penn Avenue in the Sheffield Terrace section of town and provided residents with a popular pastime for many years. (Courtesy of Butch Latone.)

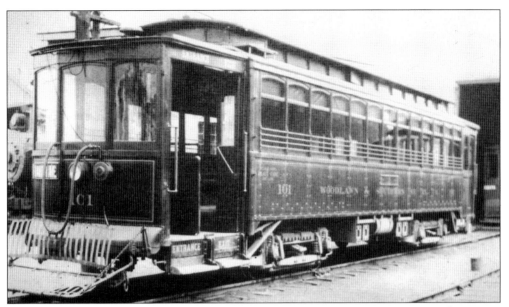

When J&L planned and designed the town, public transportation was a top priority, and street car lines were installed from inside the mill to the intersection of Main Street and Brodhead Road. Service began November 22, 1910, and continued through March 27, 1937, when streetcars were replaced with buses. The trolley car here is seen leaving the depot with another car behind it.

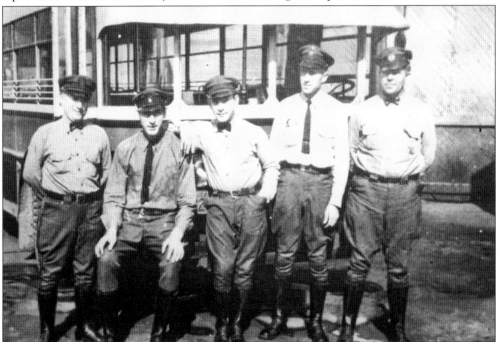

The year 1937 was one of progressive change for the city. The Woodlawn and Southern Motor Coach Company would replace the Woodlawn Street Railway Company as the city's transportation provider. New, gasoline-powered buses provided more of the city's residents with access to public transportation. The trolley line was restricted by its rail system, whereas the buses could go anywhere there was a street. This photograph shows the first crew of drivers for the new bus line.

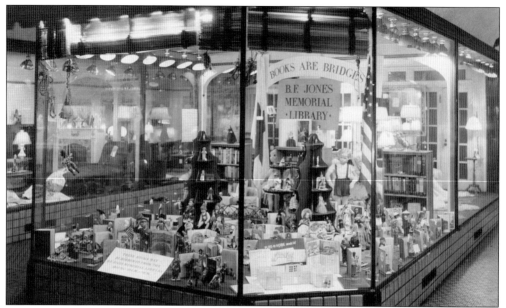

Plodinec's Furniture Store was a popular business located at 362 Franklin Avenue. The center displays in the store windows changed throughout the year. This exhibit was on loan from the B.F. Jones Memorial Library and featured books and toys that were available at the library. A trip to Plodenic's to see the elaborate Christmas display was an Aliquippa tradition.

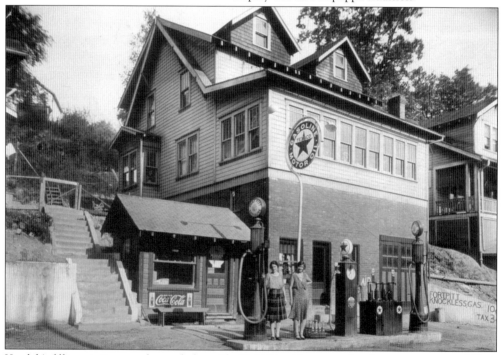

Kwolek's filling station was located along Sheffield Road between the downtown area and New Sheffield. This c. 1940 photograph advertises Texaco gasoline and motor oil. They also sell Fort Pitt Knockless Gasoline for 10¢ per gallon plus 3¢ tax. Note the height of the gravity-fed visible pump to the left of the ladies in this photograph.

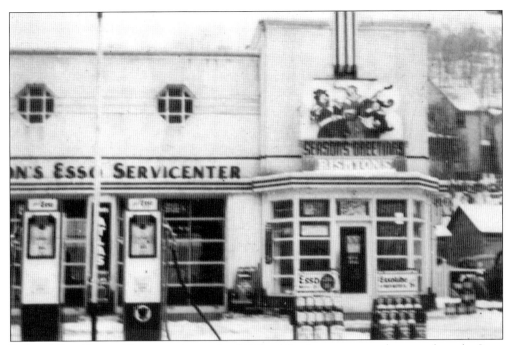

Bishton's Esso Service Center was located at 549 Franklin Avenue, across the street from the State Theater. This winter scene from the mid 1950s advertises "Seasons Greetings" from Bishtons. This gas station fell victim to the growing needs of the community when the addition was made to the post office.

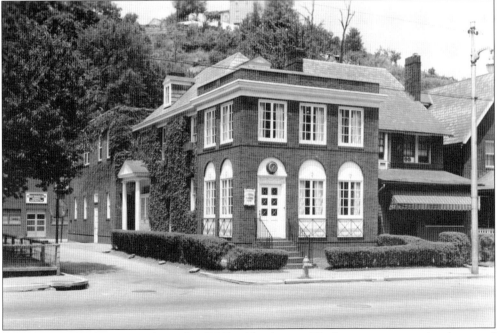

The Douds Funeral Home was located at 698 Franklin Avenue. The business was owned and operated by Edward Douds, a descendant of the landholders, who sold their property to J&L for construction of the mill. The Douds funeral home was one of several located on Franklin Avenue.

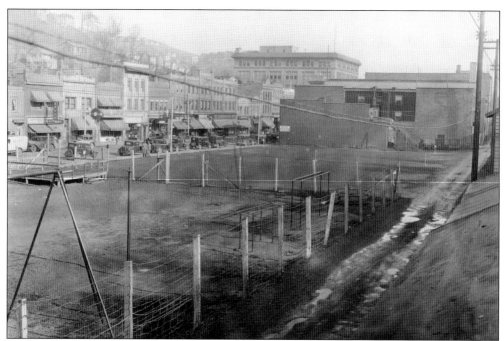

The 1928 photograph above shows the area where the future Aliquippa United States Post Office would be built. Construction continued throughout the Great Depression, with the dedication taking place in 1936. The interior of the building featured a mural painted as part of President Roosevelt's New Deal. Artists were commissioned to travel the United States to capture images of America. The mural in the Aliquippa Post Office was painted by Niles Spencer and featured a mill, billowing smoke, a train, and a scenic hillside as the background. There were over 1,200 original works of art installed in post offices across America. Many of these works, including the Aliquippa mural, are archived at the Smithsonian American Art Museum in Washington, DC. The postcard, featured below, shows the post office as it was completed in 1936.

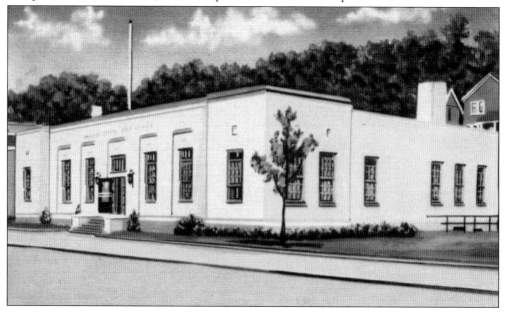

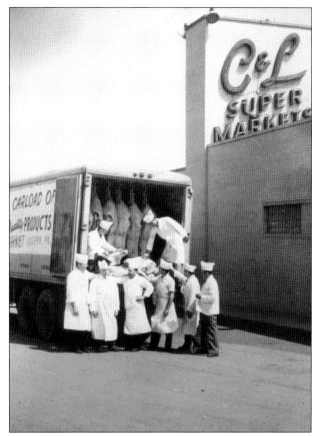

The C&L Supermarket was owned and operated by the Borsani brothers. The Borsani family opened their first store in Plan 12 in 1943 and then relocated for a brief time to Franklin Avenue after World War II. The brothers moved their store to New Sheffield in 1953. The C&L served the public at this location for 35 years. On October 22, 1988, one of the town's cherished landmarks closed its doors. For many years, local businesses provided financial support to the town's many Little League teams. The photograph below shows the players and coaches of the C&L-sponsored team. Note the C&L logo emblazoned on the uniforms.

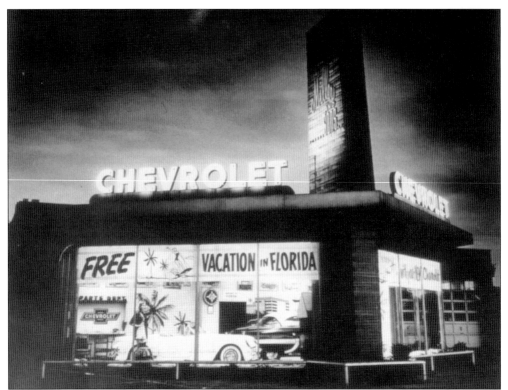

Miller and Sons Chevrolet was a landmark business in Aliquippa. It was founded by Frances X. Miller of St. Louis, Missouri, in 1948. Upon applying for a dealership from the Chevrolet Division of General Motors, Miller was informed that the only one available was in Aliquippa. Mr. Miller and his two sons, Donald R. and Frances X. Jr., opened the dealership on Franklin Avenue. They would relocate the business to Sheffield Road and Twentieth Street in New Sheffield in 1951. Featured in these photographs are the show room and the service bays of the business. Miller & Sons Chevrolet was owned and operated by the Miller family until 2007.

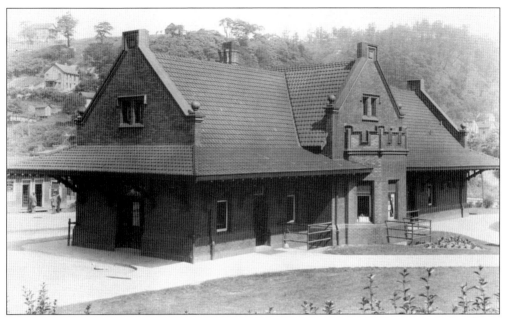

The Pittsburgh & Lake Erie Railroad built the passenger station pictured here in 1910. This classic building was a brick structure with a Spanish tile roof and a porte cochere in the front. Inside, the decor featured ornately detailed wood paneling and ceiling beams and marble baseboard throughout. Above the ticket windows in the lobby was a stained glass window with a "W" in the center for Woodlawn. This stained glass window served as a natural skylight.

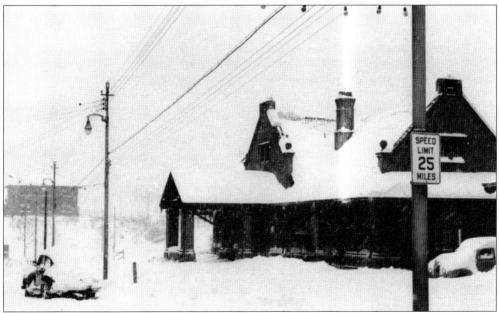

On November 25, 1950, Aliquippa was crippled by an early snow storm. The official count was 30 inches of snow fall in two days. Pictured here is the P&LE passenger station under the blanket of snow. J&L operated only those departments that were necessary. The workforce was limited to those employees that could not get home and stayed in the mill and those that lived within walking distance of the plant.

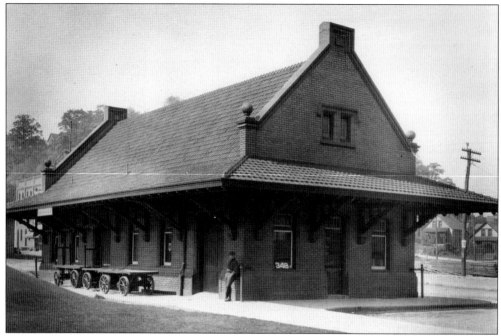

The Railway Express Agency was the first provider of high-speed freight service for small, consumable commodities that could be moved via special freight cars attached to passenger trains. The building shown in this 1918 photograph was adjacent to the passenger station on Station Street and was used exclusively for REA needs. The transfer of freight items would occur during the trains scheduled stop, which was short.

A magazine and newsstand was erected in 1913 for the convenience of the railroad's passengers. It was located immediately behind the main station building at the tunnel entrance to the passenger boarding platforms. This was a popular feature for the local commuter passengers. The newsstand was razed in 1975.

This is the US mail drop bin along the eastbound tracks of the P&LE in Aliquippa. Leather mail bags would be discharged from moving trains into this bin for pick up and delivery to the local post office.

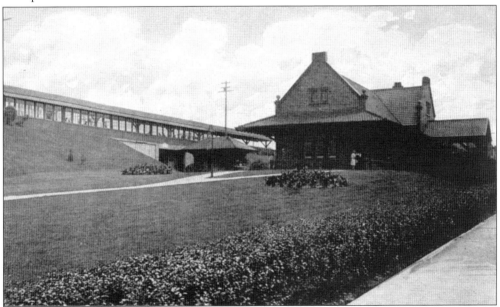

This postcard depicts the passenger station and the picturesque lawn on Station Street. A very popular train on the P&LE was the daily commuter, providing service from Beaver Falls to Pittsburgh, Pennsylvania, and back. This train was usually standing room only. It served the Beaver Valley daily until 1976.

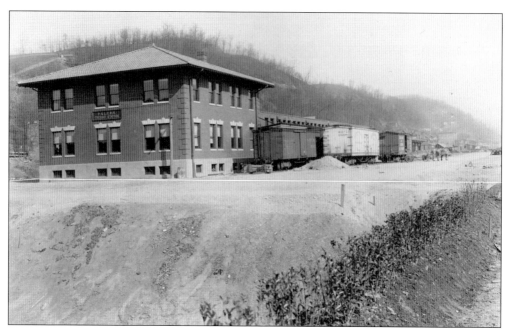

The P&LE freight station and yards, shown here on April 15, 1910, was the marshaling area for all inbound and outbound freight relating to the Aliquippa area. Railcars were offloaded from the riverside of the building, and trucks were loaded from the hillside. As automobiles gained in popularity, they were also transported by rail. Employees of the various dealerships offloaded new cars from specially designed railcars.

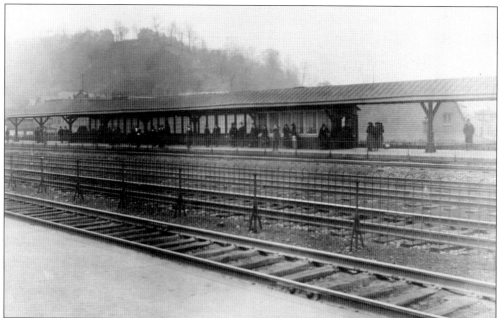

This photograph shows a busy eastbound boarding platform on the P&LE's main line at Aliquippa. Passenger service was of great importance to the P&LE, but its nickname as "The Little Giant" grew from its freight dominance. It operated only one tenth of one percent of the nation's total railroad miles, and carried an extraordinary one percent of the nation's tonnage.

This is Franklin Avenue
looking east toward the WYE
in the 1950s. The White Front
Restaurant, to the right, was a
local sandwich and coffee shop.
Note the sign for hamburgers and
coffee. The bus along the street
in the below left belongs to the
Shafer Coach Lines, another
local transportation company.

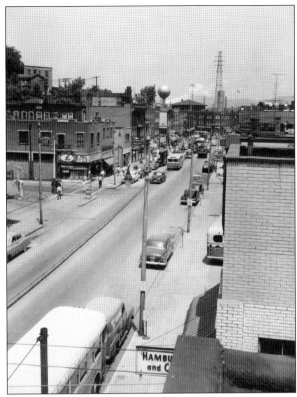

The Strand Theater, in the center
of this 1940s photograph, was
located in the Harris Building on
Franklin Avenue. The steeples of
St. Nicholas Russian Orthodox
Church can be seen above the
Strand Theater. McDonald Heights
can be seen in the above left corner.

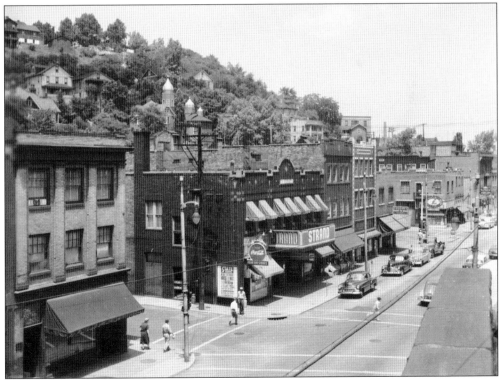

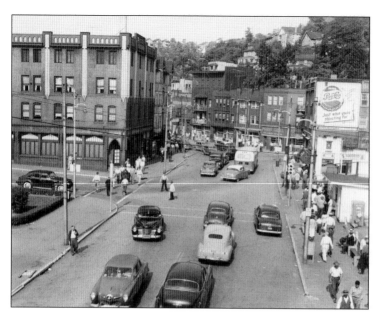

Franklin Avenue is pictured about 1950 with traffic entering and exiting the tunnel that led to the mill. Center in the photograph is the WYE, the intersection of Station Street on the left, Franklin Avenue in the center, and Hopewell Avenue to the right. The Woodlawn Hotel is on the left, the Paris Grill in the right center, and the Joseph Building is seen sporting an advertisement for Pepsi Cola.

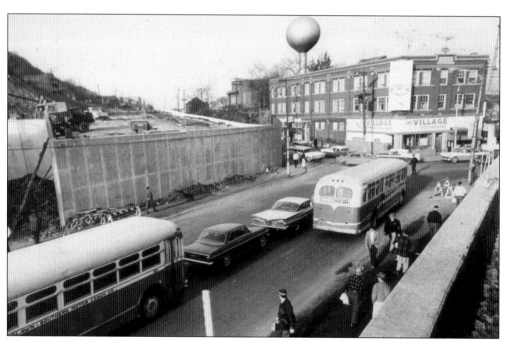

The early 1960s brought about a significant change to traffic patterns in the WYE area of town. By this time vehicular traffic had increased so much that shift change at J&L created gridlock for traffic in all directions. The solution was to construct an overpass over the WYE to carry all through traffic on Constitution Boulevard. This resulted in the elimination of many homes and businesses along Hopewell Avenue and Station Street. This photograph shows construction of the piers for the overpass.

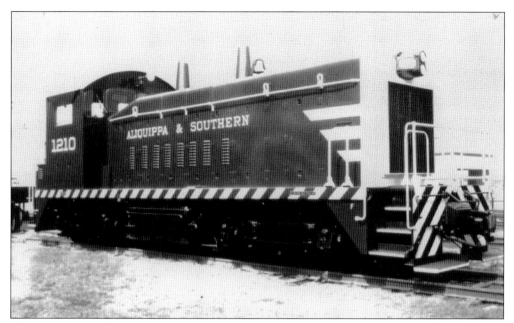

The Aliquippa & Southern Railroad was the short-line railroad that provided exclusive service to the J&L mill. It operated and maintained 90 miles of track within the plant. At its peak, it employed approximately 600 men and women. The A&S had 25 locomotives and hundreds of cars to serve the needs of the mill's operating departments. The locomotive pictured here is a diesel-electric switcher that was representative of the motive power used by the A&S.

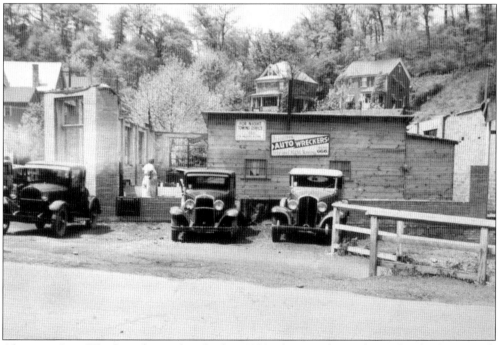

Aliquippa Auto Wreckers, featured in this late 1920s photograph, was located at the Stone Arch area of town on Waugaman Street. Their phone number is 666, and they advertise for night towing service.

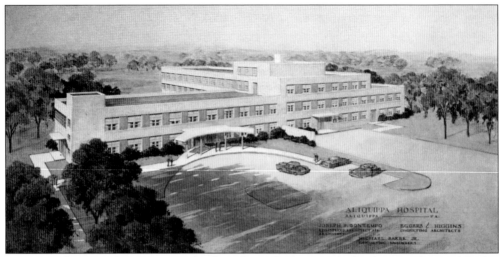

Nick DeSalle, an Italian immigrant and resident of Aliquippa had a dream; a hospital for his hometown. With drive and dedication, this man worked tirelessly to accomplish his goal. When he was refused a charter by the Beaver County Welfare Department, he traveled to Harrisburg to personally request an audience with Gov. James H. Duff. One week later, the charter was granted to Aliquippa. This photograph shows the architect's rendering of the proposed 100-bed Aliquippa Hospital.

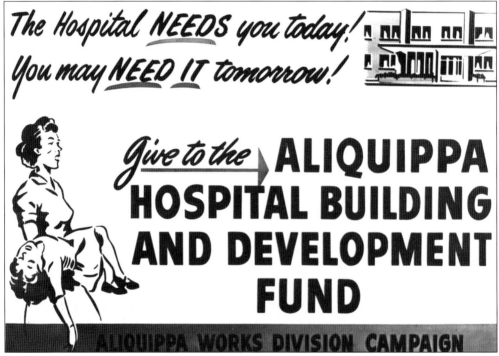

In 1953, DeSalle began the daunting task of raising funds. He approached the chairman of the board of J&L, Adm. Ben Morrell, requesting $1 million for the campaign. J&L agreed. If DeSalle could raise $1 million, the company would match the funds. Employees of J&L contributed a small amount of every pay for 25 months. Through the combined efforts of labor, industry, and individuals, over $2.3 million was raised in two years.

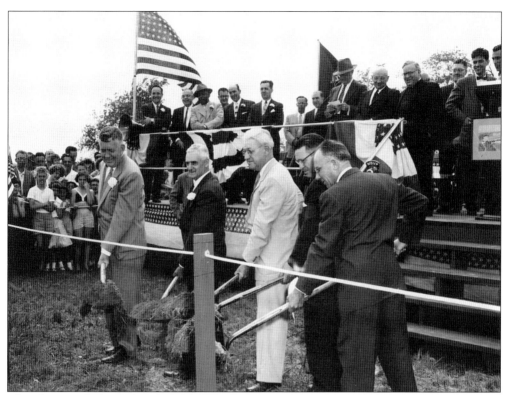

This photograph shows the ground-breaking ceremony for the hospital on May 22, 1955. J&L sold the hospital board 33 acres for $1 to build the new facility. The hospital was designed as a 100-bed facility. In subsequent years, two additions would be made to bring the total to 204 beds.

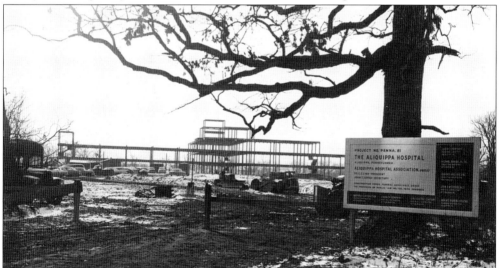

Construction of the new hospital took two years. Because of the amount of land donated by J&L, parking was never an issue for visitors. The grounds were attractively landscaped. Everything from operating rooms to the dining room was designed and built for the comfort and convenience of patients. Even the decor was considered for the therapeutic value of the patients with bright, cheerful, and attractively furnished rooms.

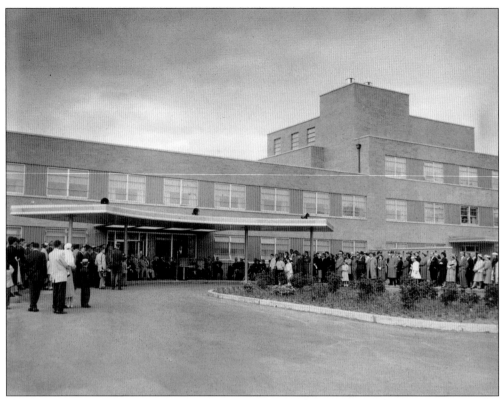

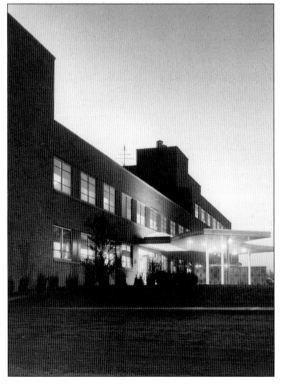

Before the hospital opened for business, a weeklong open house was held for contributors to see the results of their generosity. The number of contributors was a staggering 13,934. Tours were scheduled alphabetically throughout the week to accommodate the demand. Everyone that made a contribution had a chance to see firsthand the results of their generosity.

The hospital was dedicated on Sunday, May 5, 1957, with board member Nick DeSalle in attendance. His dream had been realized through the collaborative efforts of labor, industry, and community. A plaque displayed in the hospital foyer reflects this sentiment. "Through the united effort of the J&L Steel Corporation, its employees, and the United Steelworkers of America, Local 1211, this healing institution has been erected to serve all people, regardless of race, creed, or color."

Seven

THE GOLDEN JUBILEE

The year 1958 brought much excitement to Aliquippa as the entire town joined together to celebrate the Golden Jubilee. Starting as early as February, a committee was formed to plan, organize, and implement the weeklong schedule of activities. One of the early activities planned was a pancake breakfast to help defray the cost of the Jubilee. Through the combined efforts of the chamber of commerce, Jones and Laughlin Steel Corporation, and the Peoples Natural Gas Company, over 7,000 people were served at the pancake breakfast on April 30 and May 1 at St. Titus Church hall. Originally planned for one day, an extra day had to be added to accommodate all of the ticket holders. Local businessmen and professionals served as cooks.

The celebration took place during the week of June 29 to July 5. Over the course of the week, there were parades, softball games, including an old timer's game, fireworks, contests of all descriptions, including a greased-pig contest, and a tug-of-war. Swimming and diving competitions were held at the town's municipal pools. Church and ethnic choirs provided entertainment, along with a bagpipe band. The activities culminated with the Queen's Ball, held at Laughlin School.

Two organizations that emulated the fashions and trends of the era were the Brothers of the Brush and the Sisters of the Swish. The rules of these clubs were all about fun and memories. Many of the members dressed in period clothing for the Jubilee. The principal rule for men was to grow their facial hair or pay a permit fine to be clean-shaven. For the ladies, there were no cosmetics, perfume, or jewelry allowed or the penalty was to pay a similar permit fine. If you were caught by the Keystone Cops violating the rules, you were subject to trial by the Kangaroo Kourt and could spend time in the Jubilee jail.

The highlight of the week was the Jubilee Parade. It was a collaborative effort of the town's businesses, schools, churches, and civic organizations. The parade consisted of 31 floats and over 50 marching units. The Jubilee queen and her court were featured on an elaborate float. There were an estimated 50,000 spectators, and the parade lasted for two hours. It was a crowning moment for the town and its proud citizens.

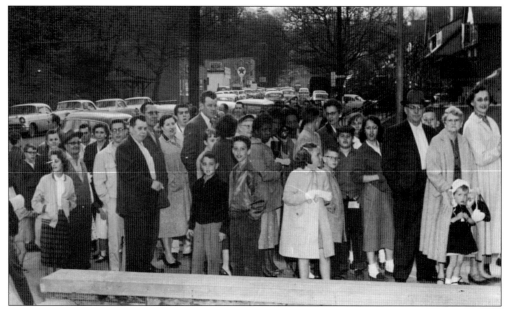

The crowd seen here was waiting their turn for the pancake breakfast served in the social hall of St. Titus Roman Catholic Church as part of Pancake Days. Over 7,000 people were served on April 30, and May 1, 1958. The original plan was for a one-day event, but the response was overwhelming, and a second day was added. The line of people stretched along Franklin Avenue around the corner to Sheffield Avenue.

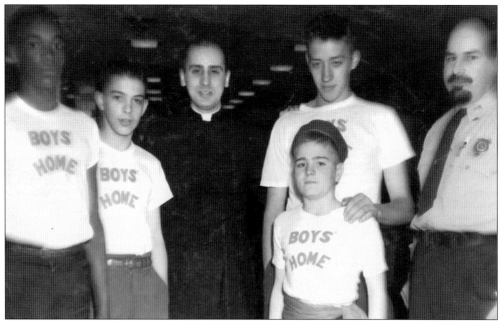

The Jubilee celebration was the result of collaboration between the town, J&L, and the local steelworkers union. The union purchased 200 tickets for the pancake breakfast and donated them to the Oakdale Boys Home. The boys were treated to breakfast and then a tour of Old Economy Village, a historic site in nearby Ambridge. Pictured here with the boys is Father Paone, priest at St. Titus, and Michael DiAddigo, chairman of the Jubilee committee.

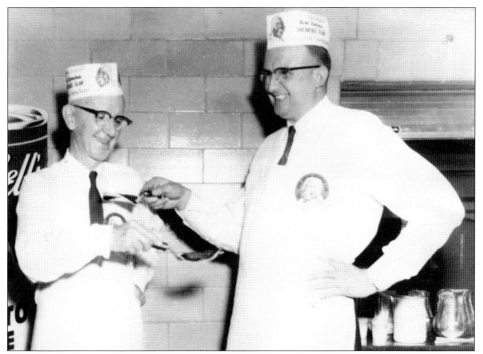

Local businessmen and professionals cooked and served the breakfast. Many local businesses generously donated all of the ingredients needed to prepare the meal. Featured here are two J&L supervisors. Earl H. Houck, left, was a supervisor for the Safety Department and John M. Gehr, right, was the Works Manager's assistant.

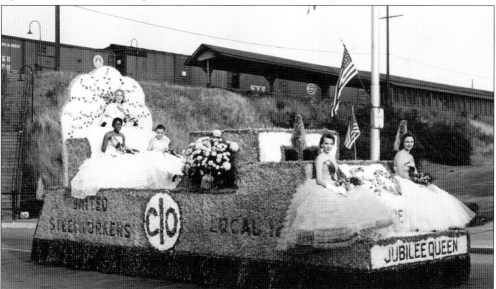

The Jubilee queen and her court are seen here emerging from the tunnel located at the WYE on Franklin Avenue. Queen Iva Lewis sits at the top of the float. Her attendants are, seated above left, Rosalyn King, and seated above right, Janice McKittrick. On the front of the float are left, Patricia Felgar and right, Janice Johnson. The queen and the court were elected by the town's citizens by casting their ballots at local businesses.

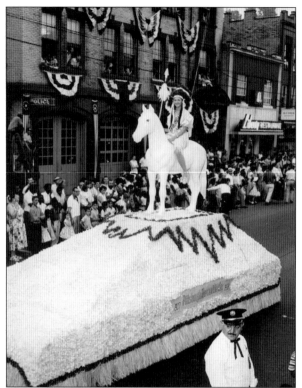

Featured here on horseback is Queen Aliquippa riding atop the Pittsburgh Mercantile float. The town adopted the queen as their namesake, since the name for the town came from the famous Native American who traveled in this area. Woodlawn Valley was a neutral trading place for the Native American tribes who inhabited this area. George Washington writes of meeting Queen Aliquippa in 1753 in the journal of his travels.

The P&LE float was built and attended by the railroad's employees. The P&LE played an integral part in the history of Aliquippa by building station stops at Aliquippa and Woodlawn in the very early years. The P&LE was a wholly owned subsidiary of the New York Central Railroad.

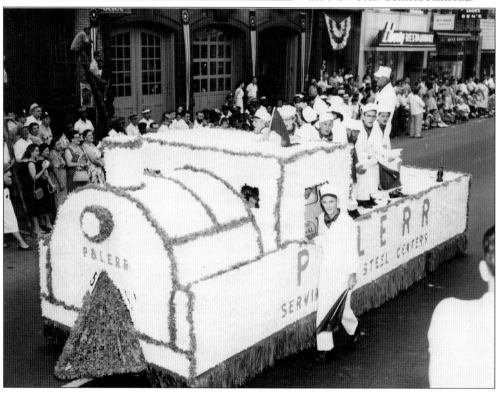

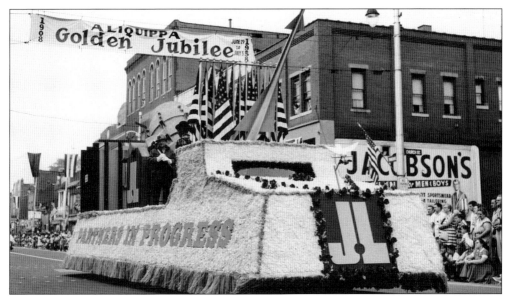

The J&L float proclaiming the company slogan, "Partners in Progress", was the first prize winner of the parade. The float featured a Bessemer Converter Furnace and the J&L trademark. "Partners in Progress" referred to the collaborative attitude that existed between the company, its employees, and the town's residents. J&L always played a significant role in the town.

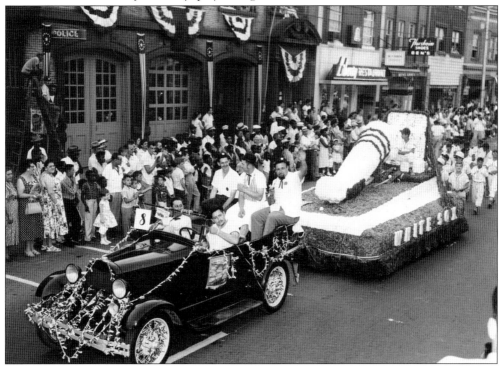

The White Sox float was entered by the White Sox Athletic Club. Their sponsored Little League team is seen marching behind the float. A few of the local businesses are recognizable in the photograph. The Liberty restaurant and Ben's Shoe Store can be seen in the above right of the photograph.

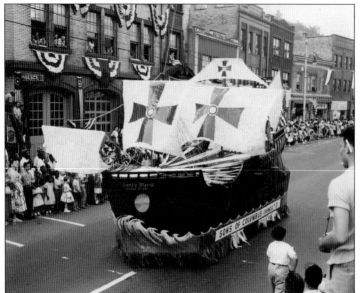

The large Italian population of Aliquippa had several social clubs in the town. The Musical Political Italians (MPI), the Sons of Italy (SOI), and the Sons of Columbus were the largest of the Italian organizations. The Sons of Columbus entered this float featuring Christopher Columbus's ship, the Santa Maria.

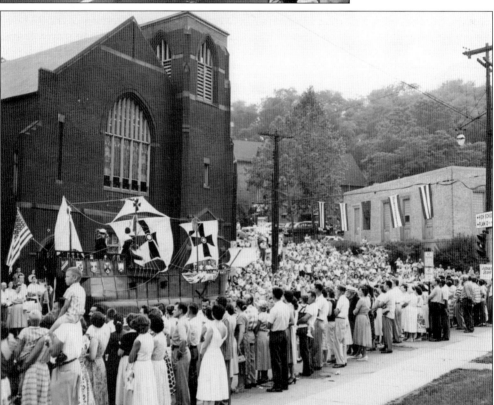

The judges' reviewing stand was located along Franklin Avenue in the area of Main Street hill. A crowd of people blanketed Main Street hill for a bird's-eye view. Spectators estimated at 50,000 lined the streets, sat on porches, and even perched on porch roofs to take in the festivities. The church in the background is the First Methodist Church. Note the directional sign pointing out Plan 12 and the high school.

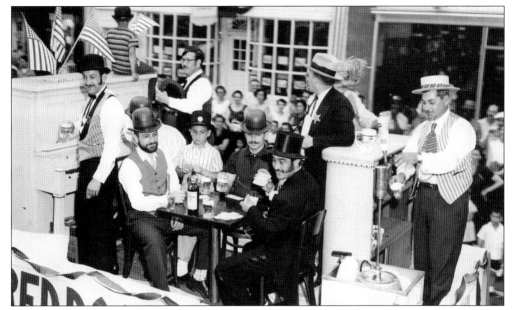

This float was sponsored by the Panther Club of West Aliquippa. The revelers of the Red Dog Saloon are, starting at the piano from left to right, Dominic Belcastro, piano player, Joseph Belcastro, and the boy on piano, Joey Belcastro. Pictured at the table are unidentified, Jimmy Belcastro, unidentified, and Tony Dercole. The sheriff leaning on the bar is Guido Lucci, and the bartender is John DeLeonardis.

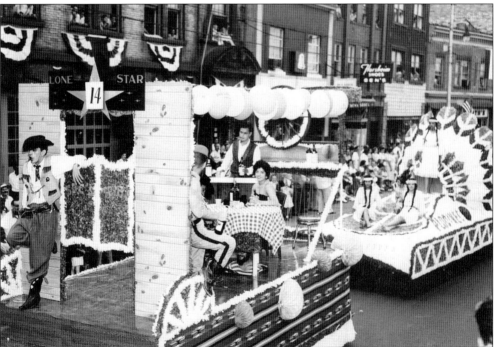

This photograph features the Lone Star Saloon and the Plodinec Furniture Store floats. The Wild West theme was reminiscent of the time the city was founded. The Plodinec Furniture store honors our Native American heritage and the town's namesake, Queen Aliquippa.

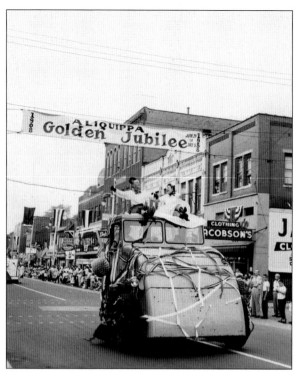

The Aliquippa street department had a fleet of street sweepers to maintain the city streets. The sweepers were a common sight in Aliquippa, easily recognized by their odd shape and battleship gray color. This sweeper was hard to camouflage even with streamers and young ladies. Businesses visible in the photograph are Jacobson's Men Store, Vater's Hardware, and Delsha's Lounge, to name a few.

There were over 50 marching units in the parade. Pictured here is the Patterson Township Volunteer Fire Department Marching Band. Units from all over the area participated in the town's celebration. Several days later, the Jubilee Parade was followed by the Fireman's Parade, which featured antique cars, fire trucks, and marching units.

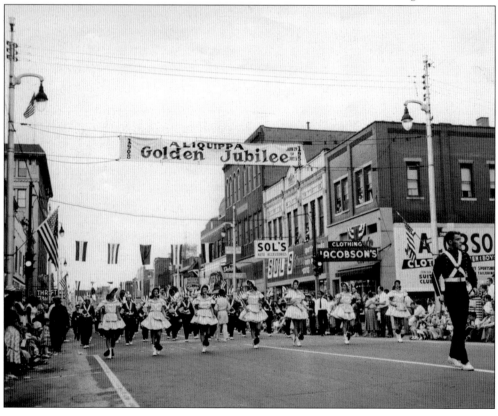

The crowd's favorite hometown band seen here is the Aliquippa High School Marching Band. Note the Native American headdresses worn by the band members. The town was particularly proud of its band. Henry Mancini, Aliquippa class of 1942, world-renowned musician and composer, was raised in West Aliquippa and is arguably the most famous member of the Aliquippa Marching Band.

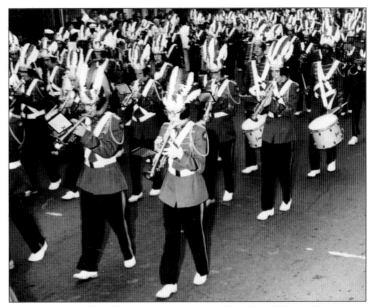

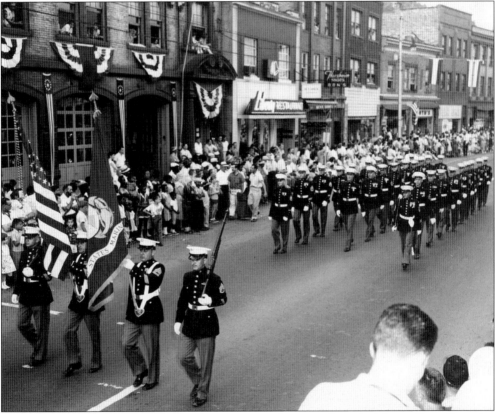

The US Marine Corps Color Guard and precision marching unit from the Marine Corps Barracks, Eighth and I Streets, Washington, DC, led the Jubilee Parade. The parade started inside the tunnel entrance to the mill and proceeded up Franklin Avenue past the reviewing stand, ending at Morrell Park.

Standing in front of his home at 143 Oliver Street in The Bricks, Theodore Kemp sports a beard and Jubilee garb. This is a classic example of Brothers of the Brush and the enthusiasm, enjoyment, and involvement of the citizens of Aliquippa.

The organizations that created the ban on clean-shaven faces and cosmetics were the Brothers of the Brush and the Sisters of the Swish. This entry in the parade featured a Conestoga wagon and riders dressed in period costumes. The horses were furnished by Joe's Riding Stable, which was owned by Joe Latone.

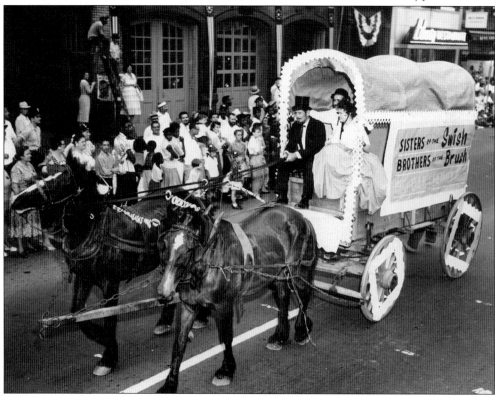

Local Keystone Kops take a break from their Jubilee duties in front of Ben's Shoe Store. Some of their duties were to arrest offenders of Jubilee laws, preside over the Kangaroo Kourt, and guard the Jubilee jail.

Some law breakers would spend time in the stocks. From left to right are Tony Kubik, Sam Urick (in the stocks), Steve "Scratch" Chalfa, Alfred "Buckwheat" Bologna, and Tony Vladovich (in the stocks), president of Local 1211. Aliquippa residents had a special talent for nicknames, and it was common for people to be known by their nicknames.

A few local outlaws are being ticketed by the Keystone Kops. On horseback are Ernie "Hawkeye" Frioni, Nick Kosanovich, Dan Oresconin, and Mr. Iacobucci. The "Kop" writing the ticket is Steve "Scratch" Chalfa.

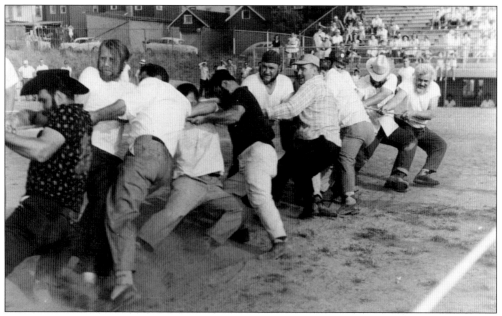

Events were ongoing at Morrell Field throughout the week. There were softball games, a greased pig contest, and fireworks displays. Several tug of war competitions were held. The contestants here are from the Town Bar and called themselves the "Stump Jumpers." Unfortunately, they placed second in the contest.

Eight

B.F. JONES MEMORIAL LIBRARY

B.F. Jones Memorial Library is often referred to as the Jewel in the Crown of Aliquippa. Not only is it a magnificent structure, it has served the people of Aliquippa since 1929 as a place of study, research, and entertainment. Elisabeth Horne, the daughter of Benjamin Franklin Jones, donated the library to the citizens of Aliquippa in memory of her father. Elisabeth Horne, of the Joseph Horne department store family, offered to build a library for Aliquippa in November 1926. In addition to the building, she would also donate $15,000 for the purchase of books. Ground was broken on July 18, 1927, and the library opened on February 1, 1929. Elisabeth Horne was present for the dedication, as was W.C. Moreland, who first suggested the plan for a library.

Elisabeth Horne engaged some of the country's foremost artisans of the time to produce a library unmatched in magnificence. Brandon Smith of Pittsburgh was chosen to be the architect. Robert Aitken, a renowned New York artist, sculpted the impressive bronze statue of B.F. Jones, which sits in the main foyer of the library. Oscar Bach, famous metalwork artist, designed and built two impressive brass arches for the library. One arch is over the entrance to the Adult Reading room and features brass medallions of man and labor. The arch over the Junior Room entrance has brass medallions depicting popular children's games of the time. Oscar Bach's other works are displayed in Rockefeller Center, The Chrysler Building, and the Empire State Building. B.F. Jones Memorial Library is listed on the National Register of Historic Places.

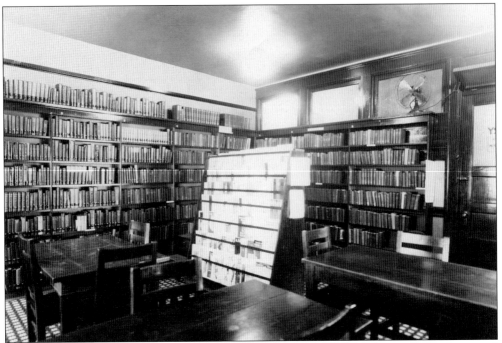

Woodlawn's first library was established by the Woman's Club of Woodlawn in 1920 and operated in the town's municipal building in the business district on Franklin Avenue. It was called the Woodlawn Free Library and was operated by the Woman's Club until the new library opened on February 1, 1929.

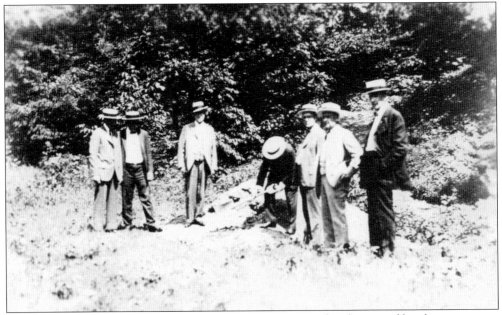

Ground was broken for the new library on July 18, 1927. Pictured at the ground breaking ceremony are, from left to right, Brandon Smith, architect; E.H. Crockett, contractor; Mr. Wilson; W.C. Moreland, holding the shovel; M.B. Moore; S.A. McFarland; and Mr. Karns. Moreland was B.F. Jones's personal secretary. This shovel is on display in the library.

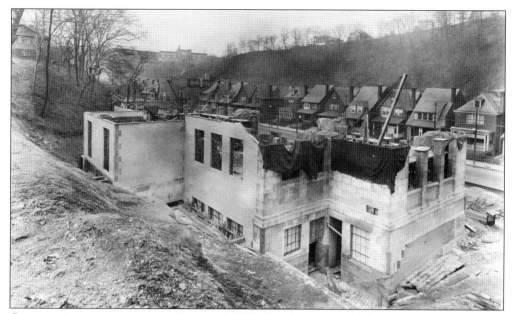

Construction was in process on January 7, 1928. Residences are visible along Franklin Avenue, and the Aliquippa High School can be seen on the hill in the background. Houses can also be seen on the hill opposite the library, which is the Plan 11 neighborhood.

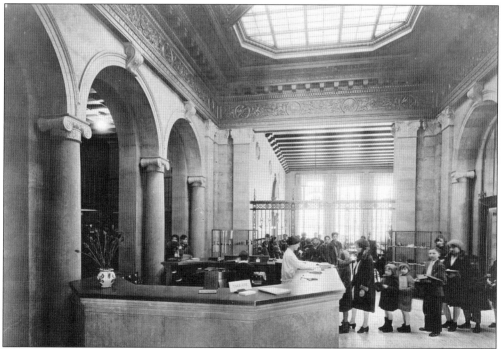

The grand lobby, shown here in January 1930, has not changed in the 84 years the library has been in operation. This photograph shows the circulation desk and the room beyond, which was the junior reading room. The brass arches over the entrances to the rooms are the work of renowned metals artist Oscar Bach. His most famous work, an inlaid stainless steel mural, stands in the lobby of the Empire State Building.

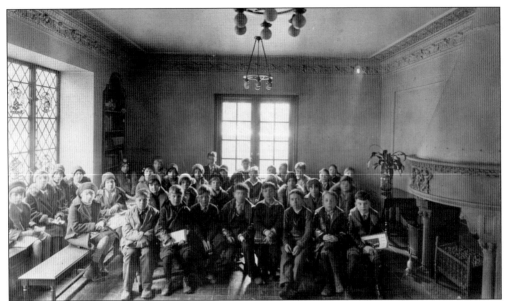

The children's library was comprised of two separate rooms, the junior reading room and this room, the story time room. Children would sit on wooden benches and raptly listen to stories. The windows are stained glass featuring Mother Goose nursery rhymes and are the work of the famous artist Henry Hunt. After 80 years of service, these beautiful windows received professional restoration. This room now serves as the director's office.

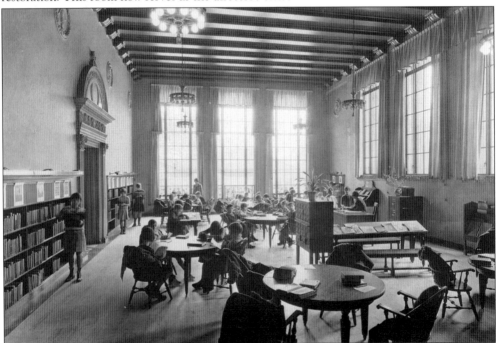

These children are researching at the library with their teacher on January 1930. The children might have walked to the library from their school, Highland Avenue Elementary, which was located behind the library. This room is currently the reference room. The grand chandeliers are still in use today and have been renovated to comply with current standards.

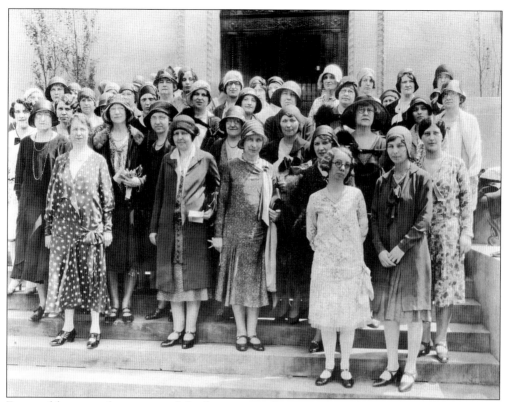

Featured here are the women of the four-county district meeting on May 7, 1930. B.F. Jones Memorial Library still serves as a meeting place for many civic and social organizations. Note the ornate brass doors that serve as the main entrance.

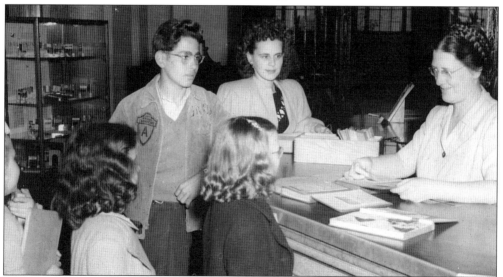

Johann Davey is assisting a young student in September 1947. The impressive circulation desk is still used today to serve the library's patrons. The display case in the left of the image is used to display library artifacts or interesting collections provided by local citizens. The majority of the furnishings are original to the library.

Susan Himmelwright was the head librarian at B.F. Jones Memorial Library when the library opened its doors on February 1, 1929. She is seen here supervising Marjorie DuBrowa as she processes new books by placing pockets inside the front cover. Students were employed as aides to help with the many tasks at the library. Books can still be found in the library with these old pockets.

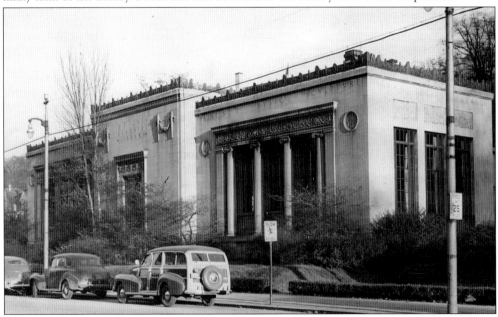

This is the library in December 1948. Note the words inscribed along the roofline: these were all subjects in the library's extensive collection, including philosophy, biology, astronomy, fiction, history, science, painting, music, sculpture, drama, poetry, and romance. The name of the library is also etched into the wall above the main entrance.

The portrait of Elisabeth Horne by artist Alfred Hoen of New York is on display in the reference room. As B.F. Jones's daughter, she was a prominent member of New York society and used her influence to obtain the services of the leading architects and artists of the time to design, construct, and decorate the library. Thanks to her generosity, the people of Aliquippa have enjoyed the benefits of a fine library for 84 years.

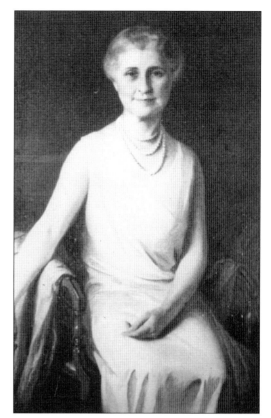

B.F. Jones was a powerful Pittsburgh businessman who helped shape the nation during his time as a steel magnate. Although he was deceased by the time the Aliquippa Works of J&L was established, his vision of a utopia for his company's workforce is evident in the town of Aliquippa and will continue to shine for years to come.

DISCOVER THOUSANDS OF LOCAL HISTORY BOOKS FEATURING MILLIONS OF VINTAGE IMAGES

Arcadia Publishing, the leading local history publisher in the United States, is committed to making history accessible and meaningful through publishing books that celebrate and preserve the heritage of America's people and places.

Find more books like this at
www.arcadiapublishing.com

Search for your hometown history, your old stomping grounds, and even your favorite sports team.

Consistent with our mission to preserve history on a local level, this book was printed in South Carolina on American-made paper and manufactured entirely in the United States. Products carrying the accredited Forest Stewardship Council (FSC) label are printed on 100 percent FSC-certified paper.

MADE IN THE